X XA 00 00A

The Photographer's Guide to Yosemite

TEXT AND PHOTOGRAPHY
BY MICHAEL FRYE

YOSEMITE
ASSOCIATION

Yosemite National Park,
California

To Claudia and Kevin, the two brightest lights in Yosemite.

Thanks to Steve Medley for his belief in this project and his editing skills; to Keith Walklet for his encouragement; and to Tina Besa and the people at Melanie Doherty Design for their vision.

Design by Melanie Doherty Design, San Francisco.
Maps by Reineck & Reineck, San Francisco.
All photographs by Michael Frye.

Printed in Singapore.

Yosemite Association
P.O. Box 230
El Portal, CA 95318

The Yosemite Association initiates and supports interpretive, educational, research, scientific, and environmental programs in Yosemite National Park, in cooperation with the National Park Service. Authorized by Congress, the Association provides services and direct financial support in order to promote park stewardship and enrich the visitor experience.

To learn more about our activities and other publications, or for information about membership, please write to the address above or call (209) 379-2646.

CONTENTS

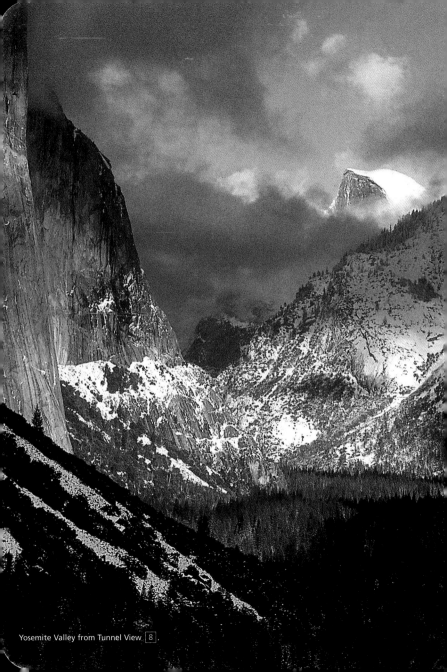

Yosemite Valley from Tunnel View 8.

INTRODUCTION

In March of 1851, fifty-seven members of the Mariposa Battalion became the first non-Indian men to enter Yosemite Valley. One member of the battalion, Lafayette Houghton Bunnell, wandered away from the rest of the party to get a better view. He later wrote,

"The grandeur of the scene was but softened by the haze that hung over the valley—light as gossamer—and by the clouds that partially dimmed the highest cliffs and mountains. This obscurity of vision but increased the awe with which I beheld it, and as I looked, a peculiar exalted sensation seemed to fill my whole being, and I found my eyes in tears with emotion."

Ever since that day, people have journeyed from all over the world to see this magnificent place. Many have shared the awe that Bunnell described upon his first sight of Yosemite Valley. And still more, artists and photographers among them, have come to Yosemite to try to portray its unique beauty.

Today, Yosemite National Park is one of the most photographed places in the world. Over four million people a year visit the area, and it's rare to see a visitor without a camera. The goals of all these photographers are as varied as the scenery in the area. At Tunnel View, on any given day, one of the most accomplished professional photographers in the country might be standing next to someone who just bought his or her first camera. But both hope to capture the beauty they see in front of them—to use the magic of photography to take a piece of Yosemite home with them.

This book is intended to help all photographers, from beginners to experts, take better pictures while they're in Yosemite. If you've never visited the park, this guide will help you find the most interesting photographic subjects and recommend the best times to photograph them. If you're already familiar with Yosemite, this book will help you discover new places you may not have seen before. And throughout the text, you will find tips to enhance your skills as a photographer.

How to Use This Book

This guide is divided into five chapters that correspond to the main areas of the park accessible by car, including Yosemite Valley, Glacier Point, Tuolumne Meadows, etc. There are, of course, countless scenic locations in Yosemite's backcountry, but to include them all would require a book six times this size (not to mention a lifetime of exploration by the author).

Accordingly, the scope of this book has been limited to areas that are within easy walking distance of a road, and to a few spots that require longer hikes 🏃🏃

but are too beautiful to leave out. Chapter 2, "The Merced River Canyon," and Chapter 5, "Mono Lake & the Eastern Sierra," cover areas that are not actually within the borders of the park, but are part of Yosemite's greater ecosystem and brimming with photographic potential.

At the beginning of each chapter are maps showing the locations described in the text that follows. For each location in the book (there are thirty-seven numbered locations in all) a detailed description is included, with suggestions about the best months to visit, the best times of day to photograph, hiking distance, elevation gain (if applicable), and more.

Additional information includes where to go, when to go, and any special equipment that might be needed. Please note that the recommended best times to photograph are only suggestions; other times can be good as well. Rarely is special equipment called for in Yosemite (see the section about equipment on page 5).

5 Valley View

GETTING THERE

From Yosemite Lodge, drive west 4.3 miles (or .8 miles west of 4 *) and pull into a large turnout on the left by the Merced River (road marker V11).*

At the back of the book *(page 114)* is **Seasonal Highlights**, a season-by-season guide to the best photographic opportunities in the park. If you are visiting Yosemite in April, for example, the spring section provides information about the finest locations to photograph wildflowers, waterfalls, and other springtime subjects.

Once you've found the right place and the right time to photograph in Yosemite, there's still no guarantee that you will make great images. Good technique and an eye for composition are as important in Yosemite as they are anywhere else. To help you improve your technique and vision, **Sidebars** with tips on photographic technique are scattered throughout the guide.

The sidebars are designed to help with special challenges you might encounter in Yosemite, such as photo-

graphing waterfalls, making nighttime photographs, and finding the proper exposure for snow scenes. Each sidebar is labeled "beginner," "intermediate," or "advanced" to help you determine whether the information is appropriate for your skill level. There is a complete list of these sidebars in the table of contents.

While the sidebars offer some useful tips, this guide is not meant to be a basic instruction book on photography. Beginners should familiarize themselves with their cameras by reading their instruction manuals and learning fundamental operating techniques. For additional guidance, consult one of the many photographic how-to books available at bookstores and libraries. Appendix B, page 124, includes a list of recommended books.

Other reference materials included are tables with sunrise and sunset times and a list of full moon dates *(Appendix A, page 122),* and a list of resources for Yosemite photographers *(Appendix B, page 124).* The latter suggests places you can buy film, get advice about a malfunctioning camera, and sign up for a camera walk or photography workshop.

Equipment

Photographing Yosemite requires no special equipment—the equipment you use elsewhere will work for most of the situations you will find in the park. Many people use a 35mm SLR (single-lens reflex) camera with several different lenses. This camera type is the most versatile for photographing the variety of situations to be encountered in Yosemite. Some photographers also use

medium- or large-format cameras to better capture the detail of the park's grand landscapes. But even with a point-and-shoot camera, you can take great pictures in Yosemite—the photographer's technique and eye are more important than the equipment used.

A selection of lenses from wide-angle (24mm or 28mm) to short telephoto (90mm or 100mm) will be adequate for photographing most landscapes in Yosemite. For wildlife photographs, you will usually need a lens at least 300mm long *(Photographing Wildlife, page 92).* A tripod is highly recommended, because it will improve the sharpness of your photographs while allowing you to use slower shutter speeds for greater depth of field *(Depth of Field, page 100.)*

Many different kinds of film can be used in Yosemite. If you have developed a preference for a type or brand of film, use it at the park. See *Choosing Film, page 68,* for a more detailed discussion of the topic. Because most people use color film, this guide is written with color photography in mind. Though many descriptions of locations detail the best times for getting good sunrise or sunset color, most of the information in this book applies to black-and-white photography as well.

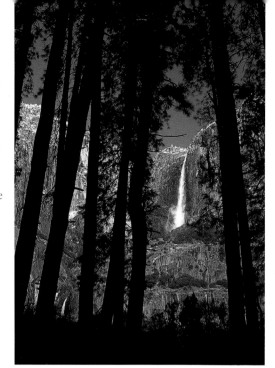

Upper Yosemite Fall from the edge of Cook's Meadow 12 .

Photographing Yosemite Without Destroying It

With over four million people a year visiting Yosemite, we all have a responsibility to minimize our impact on the park. Photographers need to be especially careful in this regard, because it is always tempting to bend the rules a little to get that special photograph. But when thousands of photographers bend the rules, meadows are trampled, wildlife becomes skittish, and delicate hillsides are eroded. Eventually, these problems result in increased restrictions on photography in Yosemite and other national parks.

You can do your part to help preserve the beauty and wildness of Yosemite by following these guidelines:

→ **Avoid trampling meadows.** It is illegal to enter the meadows and other areas in Yosemite that have been roped for their protection and restoration. You can walk through

meadows that are not roped off, but please do so cautiously. Areas with tall grasses and flowers are especially vulnerable to trampling, and the signs of a single person's passage can last for weeks.

→ **Leave things as you find them.** Regulations prohibit the removal or collection of anything in the park, including flowers, rocks, and pine cones. If you want to move a small rock, leaf, or twig to improve your composition, go ahead, but put the item back when you're done. Push live plants gently out of the way, or tie them back to keep them out of your pictures. Whatever the case, don't cut or pick any live plants— leave them the way you found them for others to enjoy.

→ **Don't feed or harass wildlife.** Feeding a wild animal alters its natural behavior and will probably end up harming the animal, another visitor, or you. Some animals, like bears, can become dangerous if they become too accustomed to people; many such bears have been destroyed in Yosemite because they did not fear humans and became aggressive. Even harmless-looking squirrels and raccoons carry rabies and bubonic plague. And while Yosemite's deer may seem tame, they are, in fact, unpredictable, wild animals. As a case in point, the only recent wildlife-related fatality to occur in Yosemite was caused by a deer, not a bear (a child was gored by a buck's antlers).

→ **Be courteous to your fellow photographers.** If someone else is photographing an animal, do your best to avoid frightening the animal away. The photographer may have spent hours getting the animal to accept his or her presence, but you may cause the animal to flee. It's also common courtesy to walk behind someone composing a shot. If you must pass in front, request permission first.

A little common sense and courtesy can go a long way toward preserving Yosemite. Your grandchildren will thank you for the kindness and thoughtfulness you practice today.

Yosemite Valley is one of the most
beautiful places in the world. Because this
special location has so many great sites
for taking photographs, only the most
extraordinary can be included here.
But wonderful images can be discovered
by letting your eyes and feet wander
in almost any direction.

This chapter is divided into two parts.
The first, called *The Classic Views,* outlines
a driving tour of the valley, with stops
and short walks to some of the best vistas.
The second section, called *Selected Hikes,*
directs you to several spectacular perspec-
tives that can't be reached by car.

YOSEMITE VALLEY

While Yosemite Valley is always beautiful, summer is its least photogenic season. During July, August, and September the valley is hot and crowded, its waterfalls are barely flowing, and it lacks the varied colors of fall. If possible, try to come at another time of year *(see Seasonal Highlights, page 114),* or plan to spend some of your summer visit in the high country *(see Chapters 3 and 4).*

The Classic Views

This section describes a driving tour of Yosemite Valley, with stops at some of the best viewpoints. The tour starts at Yosemite Lodge. To reach this spot from other locations in the valley, follow the signs to "Park Exit" or Yosemite Lodge. After passing Yosemite Lodge, the road becomes a one-way only loop around the valley.

For Selected Hikes 14 → 16 **see page 38.**

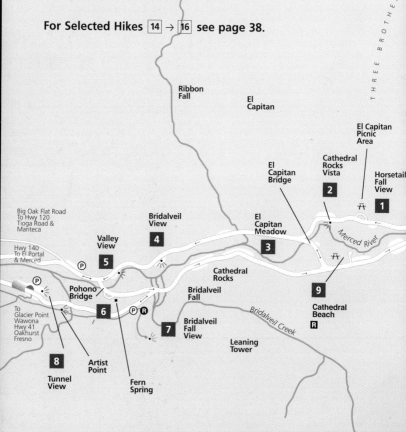

Ribbon Fall

El Capitan

THREE BROTHERS

El Capitan Picnic Area

Cathedral Rocks Vista

El Capitan Bridge

2

Horsetail Fall View

1

Big Oak Flat Road
To Hwy 120
Tioga Road &
Manteca

Bridalveil View

4

El Capitan Meadow

3

Merced River

Hwy 140
To El Portal
& Merced

Valley View

P

5

Cathedral Rocks

9

Pohono Bridge

P R

6

Bridalveil Fall

Bridalveil Creek

Cathedral Beach

R

To
Glacier Point
Wawona
Hwy 41
Oakhurst
Fresno

7

Bridalveil Fall View

8

Artist Point

Fern Spring

Leaning Tower

Tunnel View

MAP 1 → 13

10

© Reineck & Reineck 2000

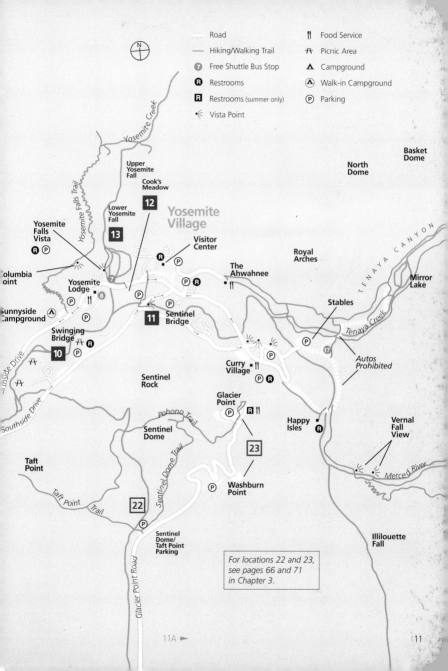

Legend

- — Road
- — Hiking/Walking Trail
- 7 Free Shuttle Bus Stop
- R Restrooms
- R Restrooms (summer only)
- Vista Point

- Food Service
- Picnic Area
- ▲ Campground
- ▲ Walk-in Campground
- P Parking

N

Yosemite Creek

Basket Dome

North Dome

Upper Yosemite Fall

Cook's Meadow

12

Yosemite Village

Yosemite Falls Trail

Lower Yosemite Fall

13

Visitor Center

Royal Arches

Yosemite Falls Vista

R P

The Ahwahnee

TENAYA CANYON

Mirror Lake

Columbia Point

Yosemite Lodge

7

R P

8

Stables

Tenaya Creek

Sunnyside Campground

11

Sentinel Bridge

P

Autos Prohibited

17

Swinging Bridge

R

10

P

Curry Village

Sentinel Rock

Sentinel Dome

Glacier Point

P

Southside Drive

Pohono Trail

Sentinel Dome Trail

P

Happy Isles

R

Vernal Fall View

Taft Point

23

Washburn Point

P

Merced River

Taft Point Trail

22

P

Illilouette Fall

Sentinel Dome/ Taft Point Parking

Glacier Point Road

For locations 22 and 23, see pages 66 and 71 in Chapter 3.

1 Horsetail Fall

GETTING THERE

From Yosemite Lodge, drive west 1.7 miles to a picnic area on the right. Pull into the picnic area and park.

BEST MONTHS

February.

BEST LIGHT

30 minutes before sunset.

📷 REFERENCES

Photographing Waterfalls and Cascades, page 20

During the last two weeks of February, the setting sun backlights Horsetail Fall (located on the east buttress of El Capitan), producing a beautiful, natural "firefall." The first widely-known photograph of this phenomenon was taken by Galen Rowell in 1973. Since then, many others have tried to duplicate this image, but none have done it better. If you want to try, come in February, on a clear evening, just before sunset. This ephemeral waterfall can flow until May, but the angle of sunlight changes and the fall no longer turns red or orange. Conversely, while lighting conditions can produce the "firefall" effect from November through January, there is rarely enough water flowing during those months.

You can photograph Horsetail Fall right from the picnic area, but the angle is better from the small clearings located about 200 yards by foot to the east. A 200 or 300mm lens is helpful at this spot. 📷

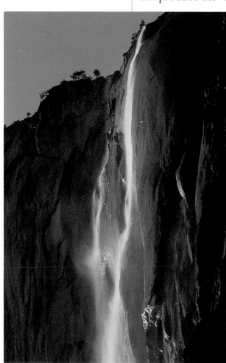

Horsetail Fall at sunset.

Cathedral Rocks Vista

From Yosemite Lodge, drive west 1.9 miles to a small dirt turnout on the left side of the road, where a view of Cathedral Rocks can be seen, and, in spring, a small pond sparkles in the foreground. This spot is located .2 miles west of 1 *. Because the turnout is in the middle of a left-leading curve, and comes up quickly and unexpectedly, move into the left lane well in advance and drive slowly.*

BEST MONTHS

April and May.

BEST LIGHT

From an hour after sunrise to mid-morning in spring; also one to two hours before sunset in spring and summer.

📷 REFERENCES

Using Filters, page 80

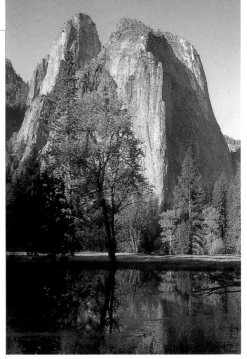

Cathedral Rocks.

This is one of the best views of the Cathedral Rocks. Although not as well-known as some other Yosemite landmarks, the Cathedral Rocks are among the valley's most varied and interesting rock formations. This spot is best photographed in spring, when the seasonal pond provides an attractive foreground. Morning (one to three hours after sunrise) and late afternoon (one to two hours before sunset) both work well. If you photograph this view early or late in the day, when there is sunlight on the rocks but not on the foreground, you might try using a graduated neutral-density filter. 📷

El Capitan Meadow

GETTING THERE

From Yosemite Lodge, drive west 2.5 miles to a large meadow on the left, with El Capitan above you to the right. This is El Capitan Meadow. From 2 , drive west .6 miles to this meadow.

BEST MONTHS

October through March, but can be good all year.

BEST LIGHT

30 to 90 minutes after sunrise, and 30 to 90 minutes before sunset.

REFERENCES

Clearing Storms, page 16

LEFT Middle Cathedral Rock and Merced River from El Capitan Bridge. RIGHT El Capitan and black oak.

From this meadow, you look straight up at one of the world's largest chunks of granite, El Capitan. Turn around and you're facing the sculptured formations of the Cathedral Rocks. If these monuments aren't captivating enough, you can stroll along the edge of the Merced River, walk through the grove of oaks in the meadow's western half, or watch ant-like climbers on the face of El Capitan.

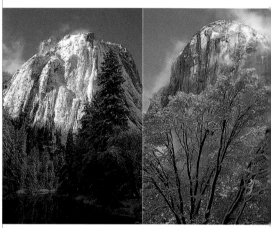

The west side of El Cap often glows with sunset light in winter, while the east side reflects the early morning sun all year. In spring, summer, and fall, you can photograph the same morning sidelight on Cathedral Rocks, or watch as they bask in warm, late-afternoon sunshine during May, June, and July. The bridge at the east end of the meadow is a good spot to photograph Cathedral Rocks.

El Capitan Meadow is a fine place to watch and photograph a clearing storm.

4 Bridalveil View

GETTING THERE

From Yosemite Lodge, drive west past El Capitan Meadow, then drop down a short hill. At the bottom of this hill, 3.5 miles from your starting point, pull into a paved turnout on the left-hand side of the road where Bridalveil Fall appears across the valley. There is a wooden post here marked "V10." This stop is 1 mile west of 3.

BEST MONTHS

March through June.

BEST LIGHT

One to two hours before sunset.

📷 REFERENCES

Photographing Waterfalls and Cascades, page 20

This turnout has a dramatic view of the ever-changing Bridalveil Fall and the Leaning Tower. In late March and April, Bridalveil is colored with golden light in the late afternoon (best about an hour before sunset). In May and June the best light is about an hour-and-a-half before sunset, after which the sun's rays are cut off by the cliffs. From July (earlier in dry years) to February the water level in the fall is usually low.

Gathering storm over Bridalveil Fall.

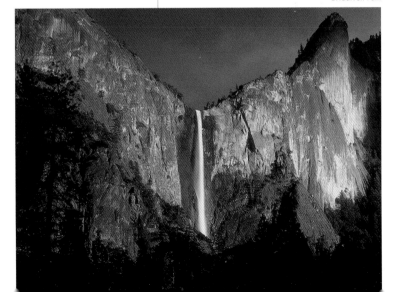

Clearing Storms

When a storm clears over Yosemite Valley, the sun peeks through the clouds to spotlight the cliffs, while mist drifts across rock faces. At these moments, the valley is at its most beautiful.

If you survey the photographs reproduced in this and other books, or on calendars and cards of Yosemite, you will find that many of the best images were taken during dramatic changes of weather.

While capturing this drama on film requires some luck, you can increase your odds by coming to Yosemite in winter, the season with the most rain and snow. Unsettled weather can occur in the park in the spring and fall as well, and spectacular summer thunderstorms occasionally descend on Tuolumne Meadows and the high country.

A clearing storm is even more magical when it breaks at sunrise or sunset. If you are fortunate enough to be in Yosemite at such a time, you will

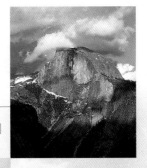

Clearing storms create dramatic light on subjects like Half Dome (RIGHT) 14 and El Capitan (BELOW) 5 .

Throughout this book you will find suggestions about the optimal times and seasons for photographing many of Yosemite's best views. On a stormy day you may wait patiently at a promising location but never glimpse a single ray of sunlight. On the other hand, you may be rewarded with the sort of spectacular light show that fair weather photographers never see. One of the most likely subjects to be struck with golden light at the end of a stormy day is Half Dome. See locations 11 , 12 , and 23 . When a storm breaks up at sunrise, location 9 (Cathedral Beach) is a good place

be faced with the dilemma of deciding where to photograph. Is the sun going to break through the clouds at sunset and hit El Capitan, for example, or will it illuminate Half Dome instead?

to capture clouds swirling around El Capitan with a beam of morning sunlight striking its southeast face.

Try using a graduated neutral-density filter when your composition includes cliffs lit by the sun and a foreground in shade (Using Filters, page 80).

5 | Valley View

GETTING THERE

From Yosemite Lodge, drive west 4.3 miles (or .8 miles west of 4) and pull into a large turnout on the left by the Merced River (road marker V11).

BEST MONTHS

All year.

BEST LIGHT

Late afternoon to sunset all year. Early morning from November through February.

REFERENCES

Using Filters, page 80

There is always something to photograph here, in any season. Not only is there a panoramic view, with El Capitan on the left and Cathedral Rocks and Bridalveil Fall on the right, but the Merced River flows by your feet, providing reflections and a variety of interesting foregrounds. An hour before sunset, El Capitan or the Cathedral Rocks (and sometimes both) are flushed with a golden glow. In winter, El Capitan receives this late afternoon light; in summer, it's Cathedral Rocks. Around the equinoxes (March 21st and September 21st), both landmarks are illuminated as the sun sinks.

Nice early morning sidelight cuts across the face of El Capitan about an hour after sunrise ►

El Capitan, Cathedral Rocks, and Merced River from Valley View.

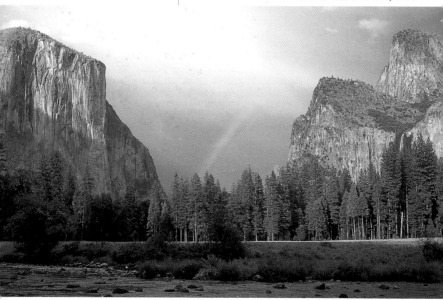

from November through February. Also, look for dogwoods in bloom in this area in early May. You may want to use a graduated neutral-density filter if the rocks are in the sun but the river is in the shade. 📷

LEFT El Capitan at sunset from Valley View.
BELOW Pacific Dogwood near Fern Spring.

6 Pohono Bridge and Fern Spring

GETTING THERE

From Yosemite Lodge, drive west 4.6 miles (or .3 miles west from ⑤). At the junction (there's a stop sign in the left lane) make a left turn onto Pohono Bridge, following the signs toward Highway 41 and Fresno. Cross the bridge and pull into the small turnout on the right just beyond, or continue one tenth of a mile to a larger paved turnout on the right at Fern Spring (road marker V12).

BEST MONTHS

May and October.

BEST LIGHT

Shade or overcast.

📷 REFERENCES

*Photographing Waterfalls and Cascades, page 20
Color, page 46
Light, page 64
Using Filters, page 80*

If polled, the resident local photographers would rate this as one of their favorite spots. Disdaining obvious subjects like El Capitan or Yosemite Falls, many would prefer to train their lenses on the tiny waterfalls of Fern Spring, the dogwood blossoms that fill this area in early May, or the colorful leaves turned out by the dogwoods and bigleaf maples in autumn (anytime from early October to early November).

The soft light provided by shade or overcast is best for these small scenes. You may want to use a warming filter in such conditions. 📷

Photographing Waterfalls and Cascades

Yosemite has the greatest concentration of large waterfalls in the world, and photographers have countless opportunities to photograph both huge cataracts and small cascades.

If you visit Yosemite in the spring, you'll be drawn to these subjects again and again.

When photographing waterfalls, one of the first decisions to be made is what shutter speed to use. Without a tripod, you'll have to use a relatively short exposure time to freeze movement of the camera and avoid blurring the picture. If you use a tripod, you also have the option of using a slow shutter speed to blur the motion of the water, while keeping everything else in the picture sharp.

Beginners who are attempting to photograph moving water should try a variety of shutter speeds for each composition. Once the images are developed you can decide which effects you liked best. Experienced photographers often choose a fast shutter speed to freeze the motion of a large waterfall, accentuating the shape and texture of the spray; they might select a slow shutter speed to give a silky, flowing look to a small cascade.

So just how fast or slow a shutter speed do you need? The answer depends on how swiftly the water is moving, your proximity to the subject, and the focal length of the lens you're using. Generally, a shutter speed of half of a second or slower will create a good blur, and a speed of at least 1/125th of a second or faster will freeze the water's motion.

With waterfalls, all types of light can work. For small cascades, soft light is often best. With large waterfalls, frontlight can produce rainbows *(Photographing Rainbows, page 26)*, while sidelight will bring out the texture of the water and surrounding rock.

Backlight may cause the water to appear translucent. *(Light, page 64)*

When photographing waterfalls, take care to keep your camera dry. Not only can moisture damage your camera, but small drops of spray on the front of the lens will ruin the photograph.

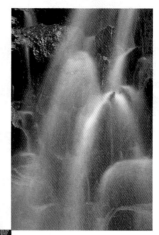

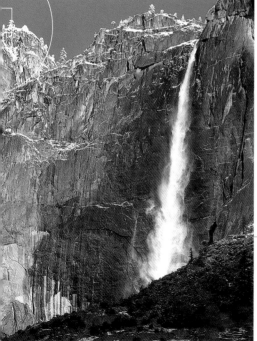

Some photographers compose their waterfall pictures on a tripod with a filter over the lens, then quickly remove the filter and expose the film. Others wipe the lens clean with a lens cloth just before taking the picture. A plastic bag will help keep the rest of your camera dry.

ABOVE A slow shutter gives a flowing look to this small cascade. LEFT The texture of Upper Yosemite Fall is captured with a fast shutter speed.

7 Bridalveil Fall

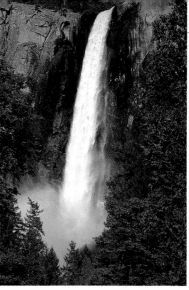

Bridalveil Fall with rainbow.

GETTING THERE

From Yosemite Lodge, drive west 4.6 miles, turning left at the junction and following the signs for Route 41 to Fresno. After another .9 miles (5.5 miles from Yosemite Lodge) get into the right lane, then turn right onto Highway 41 towards Wawona and Fresno. Almost immediately, make a left turn into the Bridalveil Fall parking lot. From 6 , drive east on the one-way loop road .8 miles, turn right onto Highway 41 to Fresno, then make the almost immediate left turn into the Bridalveil Fall parking lot.

BEST MONTHS

Late March through June.

BEST LIGHT

Late afternoon (one to three hours before sunset).

REFERENCES

*Photographing Waterfalls and Cascades, page 20
Photographing Rainbows, page 26
Light, page 64*

This is a perfect place to experience the roar and spray of a waterfall, and to photograph rainbows and a cascading creek. From the parking lot, you can see a rainbow stretch across Bridalveil Fall late on spring afternoons (about five o'clock in early April, six o'clock by June). The rainbow is first visible at the base of the waterfall, and then moves up as the sun sinks.

A five minute walk from the parking lot takes you to Bridalveil's base. In spring you'll receive a thorough soaking, but it's worth getting damp to experience the power of the waterfall, even if it's too wet to take photos. Rainbows can be seen from the waterfall's base at about 5:30 p.m. in April, 6:30 p.m. by early June. You will need a wide-angle lens to fit the whole waterfall in the picture from this spot. Please use caution: the trail and the rocks at the bottom of the fall are extremely slippery and dangerous when wet.

Below the waterfall, Bridalveil Creek breaks into several channels. A trail leads from the parking lot across three stone bridges, that provide access to several beautiful cascades along the creek. These usually are best photographed in the shade. 📷

8 Tunnel View

GETTING THERE

From Yosemite Lodge, drive west 4.6 miles. Turn left, following the signs for Highway 41 to Fresno. After .9 miles (5.5 miles from Yosemite Lodge) you will reach another junction. Turn right here, again following the signs for Highway 41 to Fresno. In 1.6 miles, just before the entrance to a tunnel, pull into the large parking area on the right. From 7 , continue on High-way 41, driving south 1.6 miles to the large parking area just before the tunnel.

BEST MONTHS

March and September, but can be good any time of year.

BEST LIGHT

Late afternoon to sunset. Also good in early morning, especially if there are some clouds.

📷 REFERENCES

Clearing Storms, page 16

This is the classic and world famous view of Yosemite Valley, immortalized by Ansel Adams. From this point in 1944 he took *Clearing Winter Storm,* an image that captures the essence of the park like no other.

The panorama from Tunnel View displays Yosemite's flat, winding valley floor, bounded by tremendous cliffs. El Capitan guards the entrance on the left, with Cathedral Rocks and Bridalveil Fall to the right. Beyond are Sentinel Rock, Half Dome, and Cloud's Rest.

Great photographs have been taken from Tunnel View in the morning, but all have benefited from extraordinary cloud formations. Late afternoon (about an hour before sunset) is usually better, although some clouds are still essential. On winter afternoons, El Capitan will be lit by the lowering sun, while Bridalveil Fall and Cathedral Rocks are in shadow. In summer, it's the opposite: Bridalveil receives late sunlight, while El Cap is dark. The ideal time to photograph this scene is around the equinoxes (March 21st and September 21st), when both sides of the valley are warmly lit at sunset. Naturally, this is a great site from which to photograph a clearing storm. 📷 ►

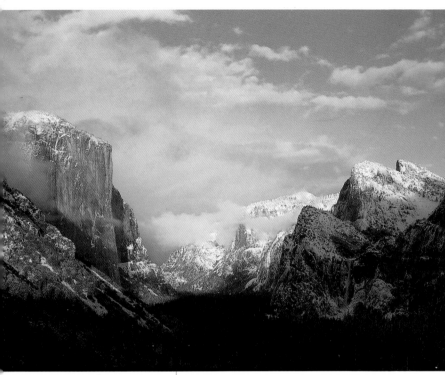

Yosemite Valley
from Tunnel View.

Those willing to hike can escape the crowded viewing area and get a slightly different perspective. Take the trail that begins at the parking lot on the south side of the road, opposite the main viewpoint. After ascending 500 vertical feet up several switchbacks, this path meets the old Wawona Road. Turn left and follow the roadbed as it gradually descends toward Yosemite Valley. In about a half-mile you will reach Artist Point, which offers a view similar to that at Tunnel View, but from a higher perspective.

9 Cathedral Beach

GETTING THERE

From Yosemite Lodge, drive west 2.4 miles. Stay left and make a left turn onto the El Capitan crossover (signs will indicate "Yosemite Village"). In .3 miles, make a left turn onto the one-way loop road heading back (east) into the valley. Proceed just one-tenth of a mile, and turn left into the Cathedral Beach picnic area. If the gate is closed, then park at one of the turnouts just beyond and walk in. To reach this spot from 8 , drive back down Highway 41 1.6 miles and turn right back onto the one-way loop road. The Cathedral Beach picnic area is on the left 1.7 miles further, and one-tenth of a mile past the El Capitan crossover (where signs will indicate Highways 140 and 120).

BEST MONTHS

All year.

BEST LIGHT

Early morning (30 to 90 minutes after sunrise) all year. In winter, 30 to 60 minutes before sunset.

From the picnic area, walk down to the large beach along the Merced River. This spot provides breathtaking views of El Capitan with the Merced River in the foreground. You will need a wide-angle lens to fit both into the picture.

This is one of the best sunrise spots in Yosemite Valley, as the east side of El Capitan catches early morning sunlight in any month. The period just before sunset can also be good in winter, when El Cap's profile will be lit by the setting sun.

A short walk upriver (east) will be rewarded with fine views of the Three Brothers (best light is in winter, either early in the morning or late in the afternoon).

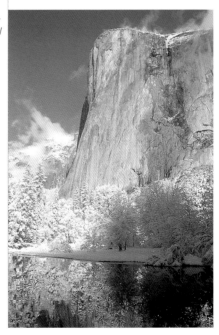

El Capitan and the Merced River from Cathedral Beach.

Photographing Rainbows

For most photographers, finding a rainbow is a matter of luck. They see a rainbow, photograph it quickly before it disappears, and hope they get lucky enough to find one again. But it doesn't have to be this way. Rainbows are actually predictable, once you learn how they work.

A rainbow appears when sunlight is refracted by small water droplets, usually in the form of rain or the mist from a waterfall. In order for you to see the rainbow, the sun has to be at your back; the rainbow forms a circle around a point exactly opposite the sun. Because the sun is always above us, the point opposite it is always located below us, so we usually only see the top half of the circle, which looks like an arch (the bottom half is interrupted by the earth). Under certain conditions, however, you may be able to see the full circle. If you hike past Vernal Fall on the Mist Trail 16 , with the sun at your back, and the waterfall is so full that you're getting soaked, a small, circular rainbow may appear right in front of you.

To find a rainbow in any waterfall, position yourself so that the sun is at your back as you look toward an area with abundant spray. Rainbows are most vivid when they arc through the base of the fall, where copious amounts of mist are generated. A rainbow will move from the top of a waterfall to the bottom in the morning (as the sun rises), and climb from bottom to top in the afternoon (as the sun sinks). Keep in mind that you may not see a rainbow when the sun is high in the sky, because the rainbow's circle will have sunk down too low to be seen.

Rainbow below Upper Yosemite Fall.

This is true at Lower Yosemite Fall 13 , where a rainbow can be seen only when the sun first hits the mist below the fall in the morning. If you can get above the spray, however (as when hiking past Vernal Fall on the Mist Trail), it's possible to see a rainbow even at noon.

On summer afternoons, dramatic thunderstorms often build over the Sierra crest. Position yourself before a dark rain cloud with the sun at your back to improve your chances of seeing a rainbow.

When photographing a rainbow, don't use a polarizing filter at full strength. It will cause the rainbow to disappear. A rainbow consists of pure polarized light, and the polarizer filters it right out *(Using Filters, page 80)*. If you rotate your polarizer to its minimum strength, however, it will actually enhance a rainbow.

Any light source, including the moon, can produce a rainbow. If you visit Yosemite in spring during the time of a full moon, you should not miss the opportunity to see a lunar rainbow. Finding the lunar variety is just like finding a solar rainbow: position yourself so that you have the moon at your back when you are looking at a waterfall's spray. ►

Upper and Lower Yosemite Falls are the best places to locate lunar rainbows, as they face south and get plenty of moonlight. One reliable viewing spot is the bridge at the base of Lower Yosemite Fall 13 . Go there when the full moon first rises and hits the spray below the fall. Keep in mind that the path of the moon changes every day, and that the moon rises approximately 50 minutes later each evening (if you see the moon rise at 9 p.m. one night, it will rise at close to 10 p.m. the next).

Most people can't see the color of a lunar rainbow, because there isn't enough light for the color-recording cones in their retinas to work. But when the moon is very bright, the bands of color may be visible to some viewers, and a color photograph of a lunar rainbow will show the bands if exposed properly.

When photographing a lunar rainbow, place yourself where you can see the rainbow without getting too wet. Too much spray on the front of the lens will cause the image to be blurred. Then follow the procedure for moonlight photographs in "Night Photography" on page 34.

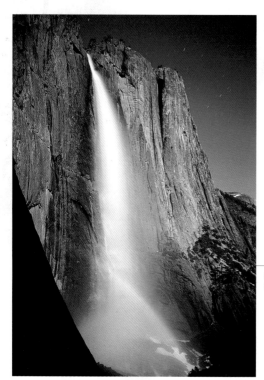

Lunar rainbow from the Upper Yosemite Fall Trail 14 .

10 Swinging Bridge

GETTING THERE

From Yosemite Lodge, drive west 2.4 miles. Stay left and make a left turn onto the El Capitan crossover (signs will indicate "Yosemite Village"). In .3 miles, turn left onto the one-way loop road heading back (east) into the valley. After another 2.1 miles (4.8 miles from your starting point), pull into a large turnout on the left. Below the turnout are picnic tables and a footbridge over the Merced River called Swinging Bridge. From 9 *, Swinging Bridge is another 1.9 miles to the east.*

BEST MONTHS

February through May (or June in heavy snowmelt years).

BEST LIGHT

30 to 90 minutes after sunrise in February; 8–9 a.m. in March; 9–9:30 a.m. in April; 10 a.m. in May and June.

REFERENCES

Color, page 46
Light, page 64
Using Filters, page 80

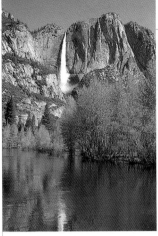

Upper Yosemite Fall and Merced River from Swinging Bridge.

This is one of the best views of Upper Yosemite Fall, with the tree-lined Merced River providing a natural foreground. In winter, beautiful sidelight angles across the falls in early morning. February is usually a better month to photograph this view than December, since the water level gradually increases throughout the winter. A graduated neutral-density filter helps when the falls are in the sun but the foreground is in the shade.

In spring (even into June and July in years with heavy snowmelt), when huge quantities of water are booming down the cliff, sunlight doesn't reach the falls until mid-morning (9 or 10 a.m.). Try using a polarizing filter to reduce glare and reflections from this brighter, harsher sunlight. In late April, shade or overcast can bring out the bright greens of budding cottonwood trees along the river.

The falls often have dried up by autumn, but this is still a perfect spot to photograph the cottonwood trees that turn flaming yellow in early November, along with the stately cliffs and their reflections in the placid water.

11 Sentinel Bridge

GETTING THERE

From Yosemite Lodge, drive east towards Yosemite Village. Cross the bridge over Yosemite Creek and proceed about half a mile to a stop sign. Turn right, drive another quarter mile, and pull into the large parking area on the right, just before Sentinel Bridge and the Merced River.

From 10, continue on the one-way loop road around Yosemite Valley. In the eastern end of the valley, you will pass the Yosemite Chapel on your right. Just beyond is a stop sign (about .8 miles from 10); turn left here, cross Sentinel Bridge and park in the large lot on the left.

Perhaps the easiest way to find this spot is to take the free shuttle bus, and get off at stop 11, Sentinel Bridge.

BEST MONTHS

Good all year, but particularly nice from November through January.

BEST LIGHT

30 to 90 minutes before sunset.

📷 REFERENCES

Using Filters, page 80

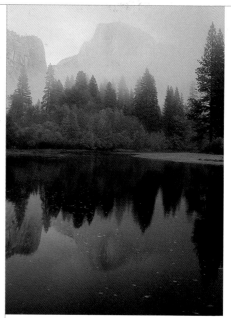

Half Dome and the Merced River.

From the upstream side of this bridge, one of Yosemite's most memorable views is presented, with Half Dome reflected in the Merced River. When the sky is clear to the west, the setting sun will color Half Dome with shades of gold, orange, and even pink.

If you photograph Half Dome at sunset, when the river is in the shade, a graduated neutral-density filter is recommended. Otherwise, it may be better to use a telephoto lens and leave the river out of your picture. 📷

Another nearby site for photographing Half Dome and its reflection lies about half a mile upstream. From the parking area at Sentinel Bridge drive north towards Yosemite

Half Dome reflected in the Merced River from Sentinel Bridge.

Village about one-quarter mile. At the stop sign, turn right, then make the first right turn into a dirt overflow day-use parking area. Walk east toward Half Dome about a quarter mile to the river. Here, too, the best light occurs from late afternoon until sunset.

12 Cook's Meadow

GETTING THERE

From Yosemite Lodge, head east towards Yosemite Village on the two-way road. After crossing the bridge over Yosemite Creek, Cook's Meadow will be the first meadow on the right. From Curry Village, Yosemite Village, or The Ahwahnee, follow signs to the park exits. Cook's Meadow is the large meadow on the left between Yosemite Village and Yosemite Lodge.

From 11, continue north on the two-way road from Sentinel Bridge toward Yosemite Village. Turn left at the first stop sign, drive .4 mile, and Cook's Meadow will be on your left. Parking is available on the right.

BEST LIGHT

Early morning, and late afternoon to sunset.

BEST MONTHS

All year.

📷 REFERENCES

*Light, page 64
Using Filters, page 80
Photographing Wildlife, page 92*

Cook's Meadow lies at the heart of Yosemite Valley. No other place offers views of so many Yosemite landmarks, including Cathedral Rocks, Half Dome, Sentinel Rock, Yosemite Falls, and Glacier Point. Within the meadow you'll find a beautiful elm tree (which turns gold in October), flowers and seasonal reflecting ponds in spring and early summer, and varied wildlife (including deer and coyotes) in the morning and evening all year. 📷

While Cook's Meadow has great views of both Upper and Lower Yosemite Fall, anyone wanting to photograph these cataracts faces a dilemma: winter brings the best light, while spring provides the most water. One solution ►

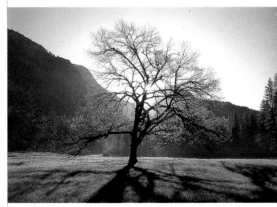

Elm tree, spring, Cook's Meadow.

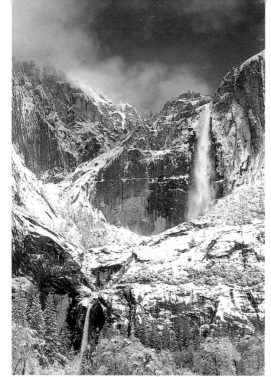
Upper and Lower Yosemite Falls from Cook's Meadow.

is to come in late winter (February or early March), when the water volume has started to increase, but low-angle sidelight still reaches the falls in the early morning, sometimes producing a rainbow. In April and May (and even June in years with heavy snow-melt), the water volume is impressive, but sunlight doesn't strike the falls until 9 or 10 a.m.

By then the sun is high and the light harsh. Try using a polarizing filter to cut the glare, 📷 or photograph the falls early in the morning when the light is softer. 📷 Also check Upper Yosemite Fall from 3 to 4 p.m. on spring afternoons, when partial backlight shines though the translucent water.

Half Dome is best photographed from thirty minutes to two hours before sunset. As the sun lowers, this rock is often flushed with shades of gold, orange, or pink. Beautiful sidelight rakes across the face of Sentinel Rock, highlighting the granite's subtle texture, in fall (October) and late winter (February) just before sunset. The lowering sun brings a golden glow to Sentinel any time of year except December and early January, when the sun sets too far to the south.

13 Lower Yosemite Fall

GETTING THERE

From Yosemite Lodge, walk toward the falls. From Curry Village, Yosemite Village, or The Ahwahnee, follow signs to the park exits, then turn right into the Lower Yosemite Fall parking lot (opposite the turn to Yosemite Lodge). On the shuttle bus route, this is stop number 7.

From 12, drive west .3 miles to the Lower Yosemite Fall parking lot on your right.

BEST MONTHS

March through May (June in heavy snowmelt years).

BEST LIGHT

Early to mid-morning.

REFERENCES

*Photographing Waterfalls and Cascades, page 20
Photographing Rainbows, page 26
Using Filters, page 80*

From this area, you will be looking nearly straight up at Yosemite Falls. Dropping 2,645 feet in three separate sections, this is Yosemite's highest waterfall. For a close-up view of the lowest portion, take the paved trail one-quarter mile to the bridge near its base. You will probably get wet from the mist created by the fall while standing on the bridge in spring; bring lens tissue so you can wipe off your lens just prior to taking a photo.

Because Lower Yosemite Fall is in a recess in the cliffs, the sun reaches it only during the middle of the day. The intense glare of this mid-day light can be softened by using a polarizing filter. An alternative is to photograph early in the morning, when the fall itself is still in the shade. The spray below the fall is struck by the sun, and sometimes rainbows are produced around 7:30 to 8:00 a.m. in April, or 8:00 to 8:30 a.m. in May.

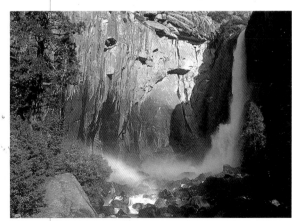

Lower Yosemite Fall with rainbow.

Night Photography

Whether inspired by Ansel Adams' famed *Moon and Half Dome*, or struck by the sight of granite cliffs glowing in the moonlight, many people attempt their first nighttime photographs in Yosemite. But it's difficult to record light when there's so little of it available. Combine this with some misconceptions about nighttime photography, and it's no wonder that few after-dark photographs are successful.

Moon and Half Dome was not taken at night. It was actually made just after sunset, three days before the full moon. In the days before it becomes full, the moon rises prior to sunset, making it possible to balance the light between the landscape and the moon—as in Ansel Adams's famous image. On the actual full moon night, the moon rises right at sunset. By the time it appears above the rim of Yosemite Valley, the landscape has been plunged into darkness. Under these conditions, the moon is much brighter than the landscape it illuminates, and it's impossible to expose both properly.

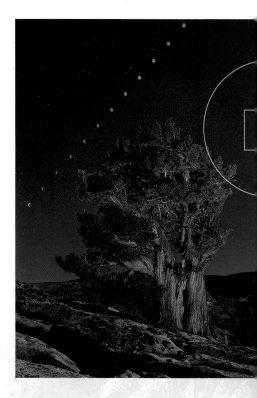

34A ▶

Multiple exposures captured the moon emerging from a total eclipse, while the juniper tree was lit with flash.

An exposure of the moon will leave the landscape completely black; if the landscape is properly exposed, the moon will be washed out.

The moon rises (and sets) approximately fifty minutes later each day. One day before it becomes full, the moon will rise about fifty minutes before sunset. This may be the perfect time to capture an image of the rising moon at an open spot like Sentinel Dome 22 .

In the confines of Yosemite Valley, the moon needs more time to rise above the valley's rim before dark, so two or three days before the full moon date may be ideal. From Mono Lake 37 , try photographing the moon setting above the Sierra peaks to the east at sunrise, one or two days after the moon is full.

See Appendix A for a list of full moon dates.

Remember, too, that a polarizing filter may help make the moon stand out more clearly in these scenes by darkening the surrounding sky *(Using Filters, page 80).*

After dark, it's also possible to make outstanding photographs of moonlit landscapes without including the moon in the picture. You will need a tripod, a camera with a "B" or "bulb" setting (most point-and-shoot cameras don't have one), a locking cable release, and a flashlight so you can see what you're doing. Many people assume that you should use fast film to photograph at night. But fast film won't really help: even with 1000 ISO film you must still use a tripod and make a long exposure. You might as well opt for slower film and get a sharper, less grainy image. ISO 100 is fine *(Choosing Film, page 68).* ➤

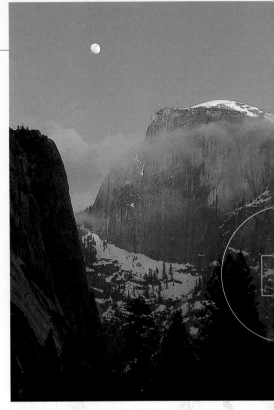

Moonrise photographs are usually made around sunrise or sunset, as in this image of Half Dome.

To make exposure times as brief as possible, leave the aperture on your lens wide open. Since this large lens opening won't provide much depth of field, it's usually best to photograph distant subjects and keep foreground objects out of your composition *(Depth of Field, page 100)*. It's difficult to focus accurately in the dark, so for these distant subjects, manually adjust the focus to infinity.

Once you've composed your photograph, focused, and adjusted your lens to its widest aperture, set your shutter speed to "B" or "bulb." Lock the shutter open with the cable release, and time the exposure with your watch. Make sure you don't shine the flashlight at the camera or at any object that might be in the photograph while the shutter is open.

The hardest part of moonlight photography is determining the length of the exposure. Here are some suggestions for moonlit cliffs and waterfalls (darker subjects need longer exposures):

With ISO 50 film
4 minutes at f/2.8;
8 minutes at f/4

With ISO 100 film
2 minutes at f/2.8;
4 minutes at f/4

With ISO 200 film
1 minute at f/2.8;
2 minutes at f/4

With ISO 400 film
30 seconds at f/2.8;
1 minute at f/4

To ensure success, you need to bracket your exposures; at minimum, take one exposure at the recommended length, one at half the length, and one at twice the length. You may even want to take one at a quarter of the suggested duration, and one at four times longer than recommended. For example, if you're using 100 ISO film, the recommended exposure is two minutes at f/2.8, so take exposures of thirty seconds, one minute, two minutes, four minutes, and eight minutes.

Another interesting nighttime photographic effect is the "star trail." To capture the movement of stars, compose your picture to include a lot of sky, focus on infinity, and leave your shutter open for at least an hour. The recommended aperture setting is f/4 or f/5.6 with ISO 100 film. As the stars move through the night sky, they create curved streaks of light across the film. This technique works best when there is no moonlight to obscure the stars.

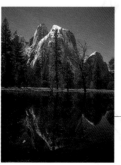

Film is so sensitive to color, even at night, that you can photograph the beautiful hues of lunar rainbows. Created by the refraction of moonlight through mist, lunar rainbows can be seen at the bases of Upper and Lower Yosemite Falls during full moon nights in spring. Photographing such phenomena is similar to photographing moonlit cliffs, as described above. The biggest challenge is finding a spot where your lens won't get wet during the exposure. See "Photographing Rainbows," page 26, for more information about finding lunar rainbows.

Moonlight was the only illumination during this four minute exposure of Cathedral Rocks.

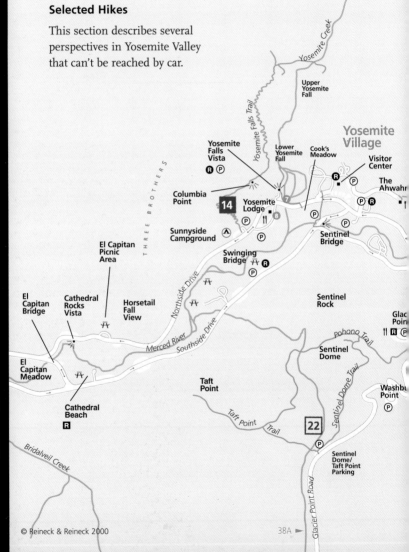

Selected Hikes

This section describes several perspectives in Yosemite Valley that can't be reached by car.

Upper Yosemite Fall

Yosemite Creek

Yosemite Falls Trail

Yosemite Village

Yosemite Falls Vista

Columbia Point

Lower Yosemite Fall

Cook's Meadow

Visitor Center

The Ahwahn

14

Yosemite Lodge

T H R E E B R O T H E R S

Sunnyside Campground

Sentinel Bridge

El Capitan Picnic Area

Swinging Bridge

El Capitan Bridge

Cathedral Rocks Vista

Horsetail Fall View

Northside Drive

Sentinel Rock

Glac Poin

Pohono Trail

Merced River

Southside Drive

Sentinel Dome

El Capitan Meadow

Sentinel Dome Trail

Cathedral Beach

Taft Point

Washbu Point

Bridalveil Creek

Taft Point Trail

22

Sentinel Dome/ Taft Point Parking

Glacier Point Road

MAP 14 → 16

38

© Reineck & Reineck 2000

38A ▶

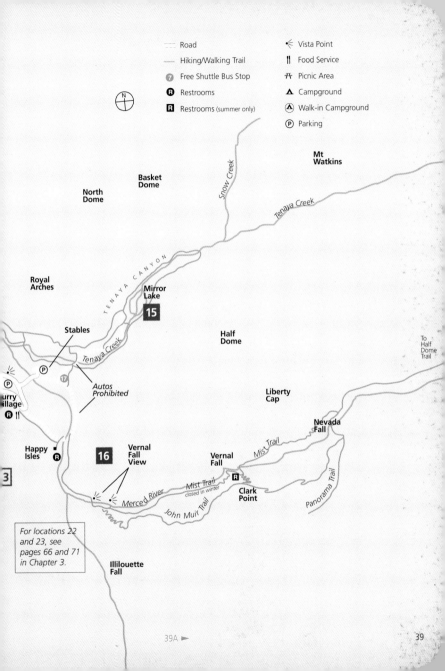

Road
Hiking/Walking Trail
7 Free Shuttle Bus Stop
R Restrooms
R Restrooms (summer only)

N

Vista Point
Food Service
Picnic Area
Campground
Walk-in Campground
P Parking

Mt Watkins

Snow Creek

Basket Dome

North Dome

Tenaya Creek

TENAYA CANYON

Royal Arches

Mirror Lake

15

Half Dome

Stables

Tenaya Creek

P

P
urry
illage
R ||

17

Autos Prohibited

Liberty Cap

To Half Dome Trail

Nevada Fall

Happy Isles **R**

16 Vernal Fall View

Mist Trail

Vernal Fall **R**

Clark Point

Mist Trail
closed in winter

3

Merced River

John Muir Trail

Panorama Trail

For locations 22 and 23, see pages 66 and 71 in Chapter 3.

Illilouette Fall

14 Upper Yosemite Fall Trail 🏃🏃

GETTING THERE

The trail starts at the back (north) side of Sunnyside Campground (across the road from Yosemite Lodge). To reach Sunnyside, follow the signs toward the park exits: the campground will be just past Yosemite Lodge on the right.

To avoid parking hassles, take the shuttle bus to the Lodge (stop 8) and walk to Sunnyside Campground.

HIKING DISTANCE

4 miles (roundtrip) with a 1400-foot elevation gain (this shortened route includes the best viewpoints, but will not take you to the top of the falls).

BEST MONTHS

March to May (or June in wet years) for Yosemite Falls. Views of Half Dome are excellent any time of year.

BEST LIGHT

For Upper Yosemite Fall, when the sunlight first strikes it in the morning (9 a.m. in early April, 10 a.m. by late May), or just before the sun sinks behind the cliffs in the afternoon (about 4 p.m.). For Half Dome, the best conditions are from late afternoon to sunset.

📷 REFERENCES

Photographing Waterfalls and Cascades, page 20

This trail shows some of Yosemite's most familiar icons from an unfamiliar perspective. A steep climb out of Yosemite Valley leads first to Columbia Point's panorama of Half Dome and the east end of Yosemite Valley, and then to a close-up view of Upper Yosemite Fall. The hike as described here takes you to some of the best vantage points along this trail, but does not reach the top of Upper Yosemite Fall, which requires an additional 2.8 miles of hiking (round-trip) and an extra 1,200 feet of elevation gain.

The beginning of the trail is hard to find. Start between the Sunnyside Campground and its parking lot, and head north toward the cliffs. When you reach the trail that runs along the base of the cliff, turn left for about one hundred feet to the start of the Yosemite Falls Trail. A mile of steep switchbacks brings you to the railing at Columbia Point. The views of Half Dome and the upper part of Yosemite Valley look best from late afternoon to sunset; a few clouds in the sky will greatly enhance photographs taken here.

From Columbia Point, climb a few more steep switchbacks to a bench that traverses the mountainside. After you round a corner, Upper Yosemite Fall comes suddenly into view. Sidelight accents the texture of the water and cliffs in the morning or afternoon (9 to 10 a.m. and 3 to 4 p.m. in spring).

From the base of the upper fall, the trail climbs through a forest wet with spray. Approximately twenty-five switchbacks later you'll find a matchless profile-view of the plunging waters.

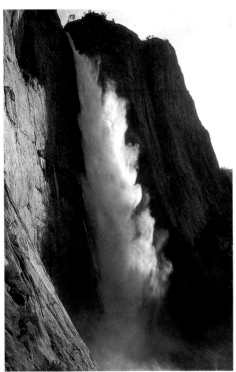

From about 9 to 10 a.m. in spring the sun backlights the translucent spray of the fall. Rainbows are also visible from 3 to 4 p.m.

First light on Upper Yosemite Fall from the Upper Yosemite Fall Trail.

15 Mirror Lake 🏃🏃

GETTING THERE

From Yosemite Lodge, Yosemite Village, or The Ahwahnee, follow the signs to Curry Village. You will reach a four-way intersection where you must stop: go straight toward the Pines Campgrounds. Follow this road until it dead-ends, and turn left into the stables parking lot. ►

Though Mirror Lake is located directly below Half Dome, it's not a good place to photograph this landmark—the immense rock appears greatly distorted from this angle. But a variety of other intriguing subjects can be photographed here, including Mt. Watkins, Tenaya Creek, and the delicate dogwoods and maples along the creek's banks.

Mirror Lake is nearly filled with sediment, but it still nicely reflects Mt. Watkins each spring, particularly from late afternoon until an hour before sunset, when the rock receives ►

To reach Mirror Lake from the stables, walk east on the shuttle bus road one-quarter mile to a junction. Turn left and follow the road another three-quarters of a mile up a slight hill to Mirror Lake.

If you take the shuttle bus, use stop number 17 (Mirror Lake). This leaves you a slightly shorter hike.

HIKING DISTANCE

2 miles roundtrip with one small hill.

BEST MONTHS

March through June.

BEST LIGHT

Late afternoon to sunset, but can also be good in early morning.

[◎] REFERENCES

Photographing Waterfalls and Cascades, page 20
Color, page 46
Light, page 64

warm, low frontlight. On your way to the lake you'll find several captivating subjects: Tenaya Creek's roaring cascades, delicate dogwood blossoms (in May), and, in October, splashes of fall color. These creek and forest scenes are usually best photographed in soft light (shade or overcast). [◎]

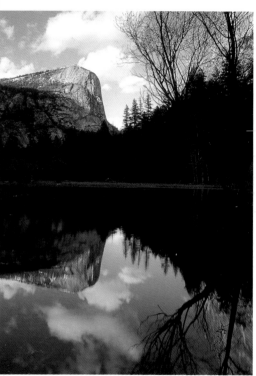

ABOVE Mount Watkins reflected in Mirror Lake.
LEFT Cascades along Tenaya Creek.

16 Vernal and Nevada Falls 🏃🏃

GETTING THERE

Start at the Curry Village parking lot, and walk down the road at the lot's southeast corner. A half-mile's hiking brings you to Happy Isles. Follow signs across the river to the start of the Mist Trail.

To shorten the hike by about a mile (roundtrip), take the shuttle bus right to Happy Isles, which is stop 16.

HIKING DISTANCE

From 2 miles (roundtrip) with a 500-foot elevation gain, to 5.9 miles (roundtrip) with a 1900-foot elevation gain, depending on your route.

BEST MONTHS

April through June, but also worth visiting in summer and fall. Portions of the trail are closed from approximately November through March.

BEST LIGHT

Late afternoon, but can be good from mid-morning on.

📷 REFERENCES

· *Photographing Waterfalls and Cascades, page 20 Photographing Rainbows, page 26*

In spring, when the waterfalls roar with snow-melt, this is one of the world's most scenic and popular day hikes. Both beginner and veteran hikers will find options suited to their energy and fitness levels. A two-mile roundtrip hike affords an excellent view of mist-blowing Vernal Fall, while a nearly six-mile roundtrip loop leads to the top of spectacular Nevada Fall. And you can always turn around at any point along the trail.

Springtime hikers invariably get soaked by the spray of Vernal Fall while ascending the Mist Trail. Some people wear bathing suits, others take rain gear, but most just let themselves and their clothes get wet, then dry out on top. Whatever approach you choose, make sure you have a way to keep your camera equipment dry.

To begin, follow the directions to the start of the Mist Trail, as detailed at left. After .8 miles you will reach a bridge with your first view of Vernal Fall. Continue another .2 miles to a junction with the John Muir Trail, but keep walking straight on the Mist Trail. One hundred yards past this junction, watch for a sign with an arrow pointing left to "View of Vernal Fall." Take the short side trail down to a large rock by the river, with a magnificent view looking up the canyon to Vernal Fall.

Throughout the spring, two to three hours before sunset, Vernal Fall receives warm, late afternoon frontlight. During May and June of heavy snow-melt years, you may be able to see a rainbow from this river-side rock just before the sun sinks behind the cliffs (about two hours before sunset). Striking photographs can also ➤

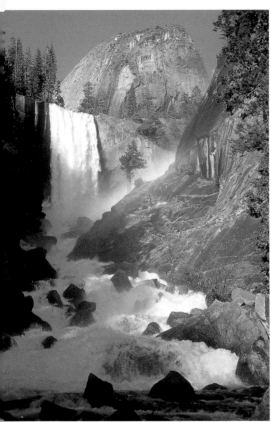
Vernal Fall with rainbow.

be made around 10 a.m. in spring, when the copious mist at the fall's base becomes backlit.

To resume the hike, return to the Mist Trail and ascend, mostly over rock steps, along the side of Vernal Fall. As you make the steep climb up the wet path, there are many good viewpoints. Unfortunately, you may have difficulty keeping your camera and lens dry while you try to take a picture. Above the wettest section of trail, however, just before you enter the trees again, there is another good outlook. You can see rainbows from this spot around noon (in spring); you will need a wide-angle lens to capture the entire panorama.

Continue steeply up more stone steps to the top of Vernal Fall. Please stay behind the railing! Every year or two someone gets swept over this waterfall and is killed.

The trail above Vernal is confusing. Just head upriver (east) until you see trail signs. After a couple of switchbacks, turn left at the trail junction onto the Mist Trail. You will soon glimpse the top of Nevada Fall, then cross a bridge over the Merced River. The trail leads north away

from the river, but soon swings south again. From a small clearing where the trail reaches closest to the river, climb down to the water's edge for a great vista of Nevada Fall. You can see a rainbow from this spot about two hours before sunset in spring. Unfortunately, it is often too wet to photograph from here.

As you continue up steep switchbacks past Nevada Fall, dramatic profile views of the cataract provide an excuse to stop and take photos. Backlight shines through the translucent water about 2 p.m., and late afternoon sidelight (one to two hours before sunset) is also attractive.

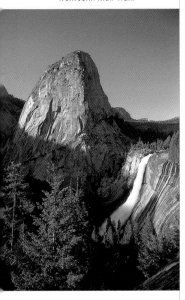

Nevada Fall and Liberty Cap from John Muir Trail.

Continue up the switchbacks to the bridge above Nevada Fall. There are pleasant spots here to rest, soak up the view, and take photos. Instead of returning via the Mist Trail, you can continue south across the bridge, making a right at the trail junction onto the John Muir Trail and following signs back to Yosemite Valley (this trail may be closed in early spring). The trail soon cuts through the side of a huge rock slab, presenting superb views of Nevada Fall and Liberty Cap. The best light is in late afternoon, just before the sun leaves the fall (about an hour before sunset).

The trail continues to Clark Point. Turn left to continue on the John Muir Trail, which rejoins the ascent route below Vernal Fall (avoiding the steep wet steps of the Mist Trail). A right turn at Clark Point takes you past a pleasant view of Vernal Fall, and back to the Mist Trail above Vernal's top. From there, retrace your route down the Mist Trail.

Color

Yosemite, with its gray and brown granite cliffs, may be better captured on black and white film than on color. If, like most people, you choose to photograph Yosemite on color film, you must look for opportunities to add color to your images.

The least effective way of creating color in a photograph is through the use of a colored filter. If you place an orange filter in front of your lens, for example, everything in the photograph will become orange. This is both unnatural and uninteresting. The best color photographs are made when colors in the image contrast (orange with blue, or red with green, for examples).

There are really only two good ways of getting color into a photograph. The first is to use the warm hues of sunrise or sunset to add color to a scene; the second is to select subjects that are inherently colorful.

Early and late in the day, a subject like Half Dome, which looks gray when the sun is overhead, can become orange, red, or purple. Often these warm colors are mixed with cool blues, creating rich color

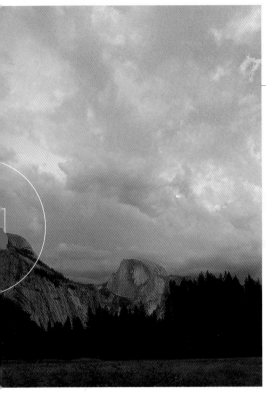

LEFT Early and late in the day, otherwise drab scenes are often flushed with color, as in this image of Half Dome 12 .
BELOW LEFT Striking compositions can be built around colorful subjects like flowers 32 .

Good color photographers often select a vivid centerpiece, like a flower or leaf, and then build a composition around it. Or they take a subject with muted tones, like El Capitan, and locate colorful foreground objects (an autumn tree or a field of flowers) to enliven the scene. Look for understated colors and delicate contrasts that most people would overlook. A photograph doesn't have to have bright reds or yellows to be effective.

Colorful subjects often look best in soft light— the kind of light found on an overcast day, or when a scene is completely shaded (*Light, page 64*).

contrasts. Throughout this book you will find tips on where and when to catch this kind of light.

Looking for colorful subjects requires developing your eye for nature's subtle hues and tints.

MERCED RIVER CANYON

The best springtime wildflowers in the Yosemite region are found in the Merced River Canyon, just west of the park. If you visit Yosemite in late March or April, plan to make a special trip to this area.

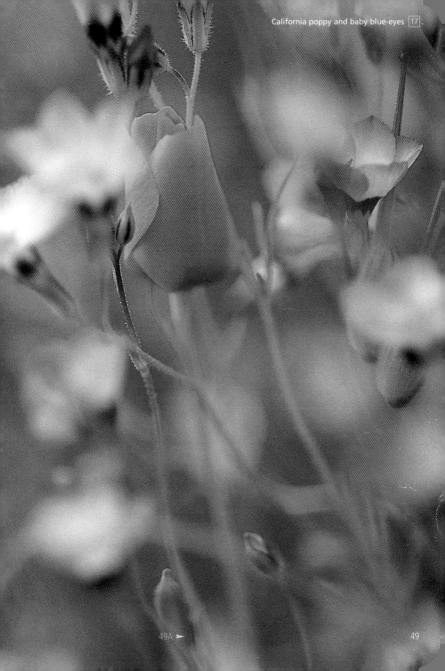

MAP 17 → 18

Merced River Canyon

Arch Rock Entrance Station

Yosemite View Lodge

To Yosemite Valley

Merced River

El Portal Market

El Portal

Foresta Road

Redbud Picnic Area

Incline Road

17

Cedar Lodge

Hite's Cove

18

Hite's Cove Trail

South Fork

Merced River

Dirt Road

Hwy 140

Sisochi Gallery

To Merced

N

Road

Hiking/Walking Trail

P Parking

Ranger Station

Picnic Area

Food Service

Vista Point

R Restrooms

© Reineck & Reineck 2000

50

50A ▶

17 Incline Road Area

GETTING THERE

From Yosemite Lodge in Yosemite Valley, drive west on Highway 140 for 15.9 miles (you will pass through the park entrance and the town of El Portal). Turn right on Foresta Road, cross the bridge, take the first left, then turn left again almost immediately. You will be heading west on Incline Road.

ABOVE **Redbud.**
LEFT **Lupine.**

BEST MONTHS

March through May. The peak of the wildflower season varies from mid-March to early May, but usually comes in early April.

BEST LIGHT

Overcast or shade for most flowers; frontlight or backlight for poppies, which open only in direct sun. ►

Incline Road follows the old roadbed of the Yosemite Valley Railroad along the north side of the Merced River, past some of the best springtime wildflower displays in the Yosemite area. The first three miles of the road are paved. Then the road turns to dirt, getting gradually rougher as you go. Since this road is a dead end, you will have to return the way you came.

Reaching some of the flower patches requires climbing up steep, grassy hillsides—nothing dangerous, but awkward and requiring that you be fairly sure-footed. Please try not to crush or trample any flowers; leave them the way you found them, so that others may enjoy them.

As you drive along the road, look for patches of flowers on the hillsides above, pink redbud bushes along the river, and cascades in the river itself. ◎ ►

📷 REFERENCES

*Photographing Waterfalls
and Cascades, page 20
Color, page 46
Close-up Photography,
page 54
Light, page 64*

Four miles from the start of Incline Road you
will find, in season, a blindingly bright patch of
orange poppies on the slope to your right.
You won't need to search—if the poppies are
there, you can't miss them. The footing on this
steep hillside is difficult, but these flowers are
worth the effort.

18 Hite's Cove Trail

GETTING THERE

*From Yosemite Valley take
Highway 140 West toward
Merced. Park at the Sisochi
Gallery (formerly Savage's
Trading Post), a small store
seven miles west of El Portal
on Highway 140. Total
distance from Yosemite
Lodge is about twenty miles;
driving time is about forty
minutes. You must sign in at
the store before taking the
trail to Hite's Cove, because
the first part of the trail lies
on private property. If you
want to start your hike
before the store opens at
9:00 a.m., you must register
the previous day.*

BEST MONTHS

*March through May. In a
normal year the peak wild-
flower bloom is in early
April, but it could come any
time from mid-March to
early May.* ►

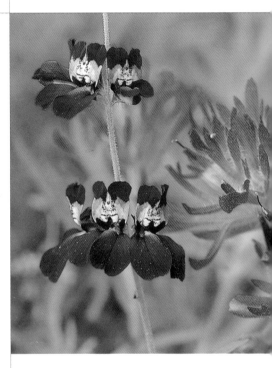

REFERENCES

Color, page 46
Close-up Photography, page 54
Light, page 64

Chinese houses and paintbrush.

This spectacular trail climbs gradually along the South Fork of the Merced River for approximately 4.5 miles to Hite's Cove. Photographers often don't make it that far, because there is so much to photograph along the way. On the first hill, just behind the Sisochi Gallery and other buildings, you can usually find a good patch of poppies. Although soft light (shade or overcast conditions) brings out the colors of flowers, poppies close up when they're not in the sun; frontlight or backlight may work better with them.

Farther along the trail grow lupine, owl's clover, Chinese houses, and many other flowers. After about two miles the trail descends to the river. Most of the flowers are now behind you, so you may prefer to turn around here. If you decide to go all the way to Hite's Cove, there are interesting remnants of the mining town that existed at the spot in the late 1800s.

Close-up Photography

Yosemite is as beautiful in its details as in its monuments. There are flowers, leaves, ice patterns, snow crystals— an endless list of subjects. While the cliffs and waterfalls are captivating, sometimes it pays to notice the beauty at your feet.

California poppies.

No special equipment is needed to photograph most subjects if they are no closer than three feet away. Some zoom lenses (and even some point-and-shoot cameras) have a "macro" setting that allows you to clearly focus on objects that are even nearer than that. Typically you can fill your viewfinder with an area that is about four inches by six inches and still keep the subject in sharp focus.

Filling the frame with smaller subjects, like tiny flowers or insects, requires special equipment. If you do a lot of close-up work you should probably own a macro lens—one that is specifically designed to focus at shorter distances than a normal lens. But if you take close-ups only occasionally, there are some less expensive options. One alternative is to use a close-up lens—one that screws onto the front of a normal lens, like a filter, and magnifies the image. Although close-up lenses are inexpensive,

until recently their optical quality has been poor. Lately some two-element close-up lenses with excellent optical quality have become available (Nikon and B+W are two widely-known brands). Though more expensive than other close-up lenses, they're worth it.

Another inexpensive choice is extension tubes—hollow tubes that mount between an ordinary lens and your camera. By increasing the distance between the front of the lens and the film, extension tubes allow your camera to focus at closer distances, in effect turning any lens into a macro lens. The only drawback to close-up lenses and extension tubes is the need to remove them to focus on normal, faraway subjects. That seems like a minor inconvenience when you consider the advantages they provide.

A tripod is another important tool for close-up photography. To get all of your subject in focus you will usually need to use a small aperture *(Depth of Field, page 100)* in combination with a slow shutter speed. A tripod will eliminate potential camera shake and also help you to compose and focus your photograph accurately, which is critical for close-ups.

The subtle colors of many small subjects—especially flowers—are brought out by the soft light of overcast or shade. Backlight creates remarkable effects with translucent objects like flowers, leaves, or grasses *(Color, page 46, and Light, page 64).*

Maple leaf
encased in ice.

CLOSE-UP PHOTOGRAPHY

WAWONA & THE

Spectacular scenery abounds in Wawona, in the Mariposa Grove of giant sequoias, and from the rim of Yosemite Valley at Glacier Point. Remember, however, that the Glacier Point Road, which provides access to the valley rim, is usually closed from early November to late May. The road to the Mariposa Grove also may be closed periodically during the winter, requiring two miles of skiing or snow-shoeing to reach the big trees.

GLACIER
POINT ROAD

22 To Taft Point Sentinel Dome

23 Washburn & Glacier Points

Glacier Point Road

McGurk Meadow

21

Bridalveil Creek

Summit Meadow

Westfall Meadows

Badger Pass Ski Area winter only

To Yosemite Valley

Road Closed Early November To Late May

Chinquapin

Yosemite West

T U R N E R R I D G E

Wawon

Hwy 41

Wawona Campgro

South Fork Merced River

MAP 19 → 23

58

58A ►

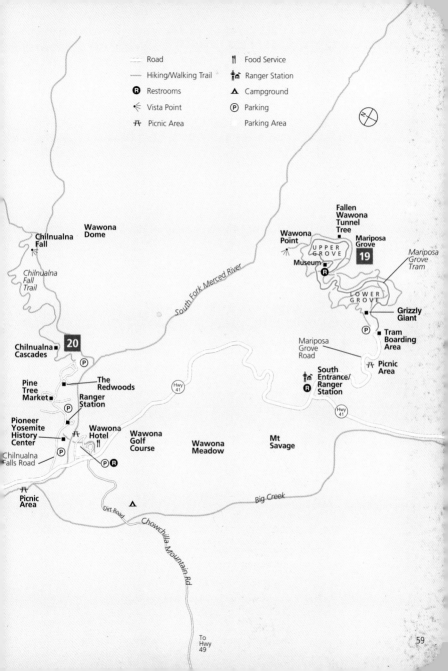

Legend

- --- Road
- —— Hiking/Walking Trail
- ® Restrooms
- ← Vista Point
- ⅂ Picnic Area
- ⅂⅂ Food Service
- 🚹🏠 Ranger Station
- △ Campground
- Ⓟ Parking
- ○ Parking Area

Wawona Dome

Chilnualna Fall

Chilnualna Fall Trail

South Fork Merced River

Fallen Wawona Tunnel Tree

Wawona Point

Mariposa Grove **19**

UPPER GROVE

Mariposa Grove Tram

Museum

LOWER GROVE

Grizzly Giant

Chilnualna Cascades **20**

Ⓟ

Mariposa Grove Road

Ⓟ Tram Boarding Area

Pine Tree Market

The Redwoods

Ranger Station

Hwy 41

⅂ Picnic Area

South Entrance/ Ranger Station

Pioneer Yosemite History Center

Wawona Hotel

Wawona Golf Course

Wawona Meadow

Mt Savage

Hwy 41

Chilnualna Falls Road

Ⓟ

Ⓟ Ⓡ

⅂ Picnic Area

Dirt Road

△

Big Creek

Chowchilla Mountain Rd

To Hwy 49

19 The Mariposa Grove

GETTING THERE

From Yosemite Valley head west toward the park exits and follow the signs for Route 41 to Wawona and Fresno. Thirty miles from Yosemite Lodge you will reach the park's south entrance. Instead of turning right to leave the park, continue ahead two miles to the Mariposa Grove parking area.

BEST MONTHS

All year, but you may need skis or snowshoes in winter.

BEST LIGHT

Overcast or shade.

📷 REFERENCES

Color, page 46
Light, page 64

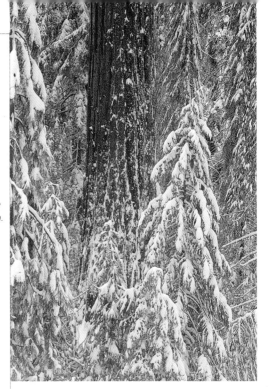

The Mariposa Grove is Yosemite's largest and finest grove of giant sequoias, but it's not always easy to reach. In winter, the two-mile road from the park's south entrance station to the grove can be closed by snow. At other times of the year the small parking lot at the grove often fills up, so you may have to park at the south entrance and take a shuttle bus.

From the grove's parking lot, you can hike into the big trees or take a tour in an open-air tram. The trams run from May to October; the cost was $8.50 per person in 1999, with discounts for children and seniors. In winter and early

spring, you will probably need skis or snow-shoes to get around among the sequoias, even if the road to the grove is open.

The Mariposa Grove has two main areas: the upper grove, with the Mariposa Grove Museum at its center, and the lower grove, which includes the Grizzly Giant (the largest tree in Yosemite and fifth largest of all sequoias). Many trails crisscross the area. One popular hike begins at the parking lot and leads to the Grizzly Giant, about .8 miles with a 300-foot elevation gain. Along the way the trail passes the Bachelor and Three Graces. All these trees make great photo subjects.

Reaching the upper grove requires a two-mile (one-way) hike with an 800-foot elevation gain, or the price of a tram ride. Heavily-laden photographers may want to minimize their exertion by getting off the tram at the upper grove, then hiking back down to the parking lot. In summer, a small meadow below the museum provides an opportunity to photograph sequoias with colorful flowers in the foreground.

It is quite difficult to capture the size and grace of giant sequoias on film. Smaller trees surround the sequoias, and it is hard to find a place where a whole big tree is in view. One option is to stand at the base of a tree and look up, using a wide-angle lens. The trees are best photographed on overcast days or when they're in the shade, but you also may find sequoias dramatically spotlit by the late afternoon sun.

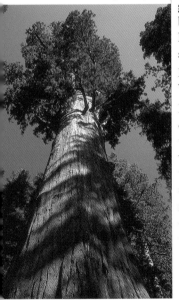

LEFT Giant sequoia at Mariposa Grove.
BELOW Looking up from the base of a giant sequoia.

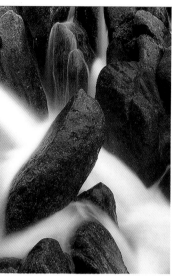

Cascade on
Chilnualna Creek.

GETTING THERE

*From Yosemite Valley head
west toward the park exits
and follow the signs for
Route 41 to Wawona and
Fresno. Twenty-seven miles
from Yosemite Lodge, turn
left on Chilnualna Falls Road
(signs indicate "Wawona").
In 1.7 miles you will reach
the end of the road and the
Chilnualna Fall trailhead park-
ing on the right.*

BEST MONTHS

March to June.

BEST LIGHT

Overcast light or shade.

📷 REFERENCES

*Photographing Waterfalls
and Cascades, page 20
Light, page 64*

Chilnualna Fall is confined to a narrow cleft
(making it difficult to photograph) and can
only be reached by a four-mile (one-way) hike
climbing 2,400 feet. A better option is to try
the photogenic cascades that can be found a steep
quarter-mile from the trailhead. Follow the trail
to the beginning of the first switchback, where
there is a good view of the largest of these lower
cascades. Some exploring will reveal other view-
points as well, but please use caution. When the
spring runoff is high the water in the creek is
extremely fast and dangerous, and the wet rocks
near its banks are slippery.

Soft, overcast light or shade is usually best for
photographing cascades. To create a soft, ethe-
real look in your photograph, put your camera
on a tripod and use a slow shutter speed to
blur the water's motion. 📷

21 Flower Meadows

GETTING THERE

From Yosemite Valley head west toward the park exits and follow the signs for Route 41 to Wawona and Fresno. Fifteen miles from Yosemite Lodge, turn left on the Glacier Point Road (signs indicate "Glacier Point"). This junction is called Chinquapin. In another 6.2 miles from Chinquapin you will reach Summit Meadow on the right. Look for a paved turnout with a restroom and picnic tables. The trailhead marked "McGurk Meadow" is located another 1.6 miles beyond Summit Meadow. The trail leads north one mile to McGurk Meadow, and south one mile to Westfall Meadow.

BEST MONTHS

June and July.

BEST LIGHT

Shade or overcast.

[photo] REFERENCES

*Color, page 46
Close-up Photography, page 54
Light, page 64*

Summit, McGurk, and Westfall Meadows feature vivid wildflower displays in summer, with their peak blooms usually occurring in July. In June, the abstract patterns of corn lily leaves also make fascinating subjects. Overcast light or shade is often best for these intimate scenes. [photo]

ABOVE Corn lilies.
LEFT Monkeyflowers.

Light

Light may be the most important aspect of photography. While beginning photographers often think in terms of depicting objects, such as mountains, trees, or people, experienced photographers know that they are merely recording the light reflected off those objects. Without good light, even the most compelling subject won't make an interesting photograph. Natural light comes in four basic varieties: soft light, frontlight, sidelight, and backlight. To make effective images, you must match your subject with the most appropriate illumination.

(1) **SOFT LIGHT**—the kind of light found on an overcast day or when a scene is completely shaded—usually works best for colorful subjects. While direct sunlight emphasizes the contrast between light and dark, soft light heightens color contrasts, and can emphasize subtle tints that would be lost in the sun. Soft light can also visually simplify complex subjects, such as forest scenes, where bright sun and shadow would produce photographs that are too busy and contrasty.

(2) **FRONTLIGHT** For colorful subjects, the next best thing to soft light is low frontlight, created by positioning the sun at your back. Since most of the shadows will fall behind your subject, the scene becomes evenly illuminated by the sun and color contrasts predominate. But use this method selectively. Frontlight can look flat and uninteresting when the sun is high or when there is no color in the subject.

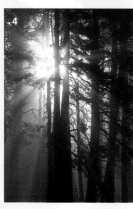
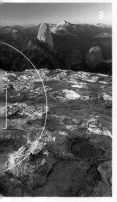

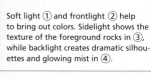

Soft light ① and frontlight ② help to bring out colors. Sidelight shows the texture of the foreground rocks in ③, while backlight creates dramatic silhouettes and glowing mist in ④.

④ BACKLIGHT—created when the sun is positioned behind your subject—also creates deep contrast between highlights and shadows. Translucent subjects, like leaves, grasses, flowers, feathers, spider webs, and waterfalls, will seem to glow with an inner light when the sun shines through them from behind. The effect is especially dramatic when a telephoto lens is used to isolate such objects against a dark background. Backlight can also be used to create striking silhouettes: place an interesting shape against a lighter background, like the sky, for an engaging profile. Whenever you point your camera toward the sun, be sure to shade your lens to prevent flare—the annoying bright spots or streaks that sometimes appear when sunlight shines into your lens.

③ SIDELIGHT, with the sun coming from your left or right, is great for bringing out the texture of subjects. Many of the granite walls of Yosemite, like El Capitan, look best when sunlight rakes across them, showing every crack and crevice in their rock faces. Since sidelight strikes one side of your subject while leaving the opposite side in shadow, it automatically creates contrast. It is, therefore, a good choice for subjects lacking color or for black and white photography. The closer the sun is to the horizon, the more dramatic all these effects of sidelight will be.

LIGHT

22 Taft Point and Sentinel Dome 🚶🚶

GETTING THERE

From Yosemite Valley head west toward the park exits and follow the signs for Route 41 to Wawona and Fresno. Fifteen miles from Yosemite Lodge, turn left onto the Glacier Point Road (signs indicate "Glacier Point"). This junction is called Chinquapin. Another 13.9 miles beyond Chinquapin (7.7 miles from 21), pull into a parking area on the left side of the road where the trailhead sign indicates "Sentinel Dome." (This location is shown on the Yosemite Valley map, page 11.)

HIKING DISTANCE

Taft Point and Sentinel Dome are both 2.4 miles roundtrip from this trailhead. The Sentinel Dome route involves a little more uphill hiking, with a 400-foot climb, compared with the 200-foot elevation gain returning from Taft Point.

BEST MONTHS

Any time the Glacier Point Road is open (usually from Memorial Day to early November). ➤

You can't go wrong, whether you chose to hike west to Taft Point or east to Sentinel Dome. Taft Point offers spectacular views of Yosemite Falls, El Capitan, Cathedral Rocks, and the west end of Yosemite Valley. In summer, sunlight strikes El Capitan early in the morning, and by mid-morning Yosemite Falls are nicely sidelit (although there will be more water in June than August). In fall (the later in fall the better) exquisite late-afternoon sun highlights El Capitan. Take a flashlight for the return hike if you plan on staying late.

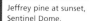
Jeffrey pine at sunset, Sentinel Dome.

BEST LIGHT

For Taft Point, early morning in summer, and late afternoon to sunset in fall. For Sentinel Dome, just after sunrise or just before sunset any time of the year.

Atop Sentinel Dome sits one of the world's most photographed trees, the famous Jeffrey pine. Although the tree is now dead, the gnarled, twisted snag still makes a great subject for photographs, as do the stunning views of Half Dome and the Yosemite high country. Just after sunrise or before sunset, the tree's weathered wood is bathed in warm, low-angle sunlight. Again, take a flashlight if you plan on staying until sunset. For a real treat, stay after dark to enjoy some of the best stargazing anywhere!

Choosing Film

One of the most perplexing problems for beginning photographers is choosing film. There are so many different films available that the options seem overwhelming.

First, determine the film size for your camera. Most cameras sold today use 35mm film cartridges. Numbers like "135-36," "135-24," or "135-12" will appear somewhere on a box of 35mm film. The 135 signifies the film size (35mm) while "36,"

"24," or "12" indicates the number of exposures you will get on that roll of film. The second most common size is APS, or Advanced Photo System. This film is packaged in drop-in cartridges for many newer point-and-shoot cameras. Among the other sizes available, 110 film comes in a small cartridge that fits some older Kodak Instamatic cameras, and 120 film is larger than 35mm and fits "medium format" cameras.

Once you know your camera's film size, you can choose from three basic film categories: color print, color slide,

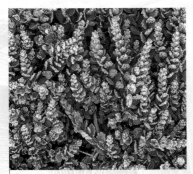

Slow speed film will capture all the detail of both large and small subjects, like this frosted plant (ABOVE) and the scenery in Cook's Meadow 12 (UPPER RIGHT).

↑ beginner intermediate advanced

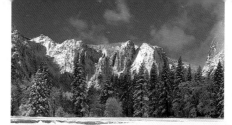

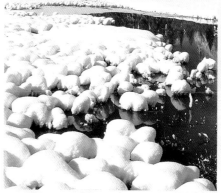

and black-and-white. All three can be used in any 35mm, APS, or medium format camera. Color print (more accurately referred to as color negative) film is popular with amateurs because it is easy to view the processed photographs; a slide projector or light box isn't needed. Print films are also forgiving. They are designed to have great exposure latitude, which means that a good print can be made even if the negative is under- or over-exposed. Because of this, color print film is the best choice for any camera that does not have manual exposure controls.

For color photographs, most serious amateur and professional photographers use slide film, for several reasons. First, slide film is less expensive to process, an important consideration if you shoot a lot of film. Second, slide film allows you to see exactly how your exposure choices affected the images. For example, if you deliberately overexposed a photograph, you will see the effect in a slide. On the other hand, a print may look as if it had been normally exposed, because the person (or machine) printing the photograph might try to compensate for your "mistake." Third, professional photographers use slide film because that is what photo editors want to see—most publications will not use negatives or prints.

Black-and-white film can be a great choice in Yosemite, a location not known for its color. Few labs handle black-and-white, but Kodak does, and every major city has one or two professional black-and-white labs. Several films also can be developed with the same processing system used for color negatives, but produce black-and-white prints. For example, Kodak Black & White+ and Ilford XP2 can be processed at almost any lab. ►

Even subjects that move, like this bobcat, look best on slow speed, fine-grained film.

Your next choice is the speed of the film you'll use. A film's sensitivity to light (speed) is designated by an ISO number—ISO 100, ISO 200, ISO 400, etc. The higher the number, the more sensitive the film is to light. In photographer's slang, a film with a high ISO rating (400 or more) is called "fast," while a film with a low ISO rating (100 or less) is considered "slow." A fast film can be used in a great variety of situations. It works well in dim light as well as in bright sunshine. But enlargements produced from fast film will appear grainy and less sharp compared with prints made from slower films. To increase a film's sensitivity to light, manufacturers must sacrifice picture quality.

Unless you never plan on making enlargements, you will benefit from using a slower-speed film, like ISO 100, for most of your photography. Although you may sometimes wish you had a faster film, ISO 100 is sensitive enough for 90% of the situations you will encounter. And most important, you will get sharp, relatively grain-free images. ISO 200 is also a good choice if you will be making only occasional enlargements.

A stratagem favored by some photographers is to carry around a variety of films, but to be effective, this requires the use of two or more cameras. Otherwise, it is inevitable that you will have slow film in your camera when you need fast film, and vice-versa.

23 Washburn and Glacier Points

GETTING THERE

From Yosemite Valley head west toward the park exits and follow the signs for Route 41 to Wawona and Fresno. Fifteen miles from Yosemite Lodge, turn left onto the Glacier Point Road (signs indicate "Glacier Point"). This junction is called Chinquapin. Another 15.6 miles beyond Chinquapin (1.7 miles from 22) you will reach a large turnout on the right-hand side of the road with a sweeping view of Half Dome and the Yosemite high country. This is Washburn Point. To get to Glacier Point, follow the road for another .7 mile to the parking area at the road's end. From there it is a short walk out to Glacier Point. (This location is shown on the Yosemite Valley map, page 11.)

BEST MONTHS

Any time the Glacier Point Road is open (usually from Memorial Day to early November).

BEST LIGHT

Late afternoon to sunset.

REFERENCES

*Clearing Storms, page 16
Photographing Rainbows, page 26*

Perched more than 3,000 feet above the floor of Yosemite Valley, both Washburn and Glacier Points afford magnificent views of Half Dome and the Yosemite high country. The panorama from Washburn Point also includes Vernal and Nevada Falls, as well as the Clark Range. Glacier Point offers an eagle's view of Yosemite Falls and the upper end of Yosemite Valley. Neither sight should be missed.

The best light for photographing these subjects occurs from late afternoon to sunset. Some clouds in the sky will greatly improve images taken from these spots. Afternoon thunderstorms often roll in from the east in summer, and Washburn and Glacier Points are great places to photograph the clouds and occasional rainbows that these storms produce. But be careful—these high, exposed locations are frequently struck by lightning. If there is lightning in the area, get inside your car and avoid touching exposed metal.

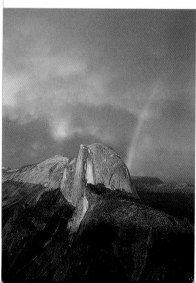

Half Dome with rainbow from Glacier Point.

THE TIOGA ROAD

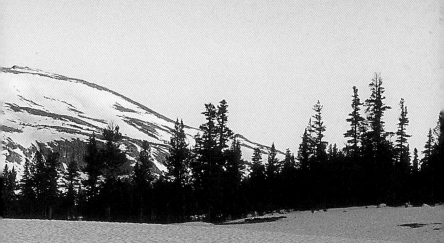

The Tioga Road traverses some of the finest scenery in Yosemite. From Yosemite Valley, at 4,000 feet, the route climbs to Tioga Pass at 9,945 feet. Along the way, travelers pass forests, flower-filled meadows, shining granite domes, sparkling lakes, and the high peaks of the Sierra crest.

The road is usually open from late May to the end of October, but the first two locations, 24 and 25, are accessible all year.

Tuolumne Peak

GRAND CANYON OF THE TUOLUMNE RIVER

Mt Hoffmann

Cathedral Creek

Tuolu

To Crane Flat & Yosemite Valley

May Lake

24

25

26

Snow Creek

Ⓟ

Pothole Dome

29

Ⓟ

Murphy Creek

Polly Dome

Hwy 120

27 Olmsted Point

Ⓟ

Tioga Pass Road

Tenaya Lake

Ⓡ Ⓟ 🏕

28

Tenaya Creek

Pywiack Dome

Cathedral Peak

Budd Creek

🚹 🅿 Ⓡ

Visitor Information Center

Tenaya Creek

Cathedral Pass

Echo Peaks

Budd Lake

Unicorn Peak

CATHEDRAL RANGE

Unicorn Creek

MATTHES CREST

Echo Creek

Cathedral Fork

MAP 24 → 34

74

© Reineck & Reineck 2000

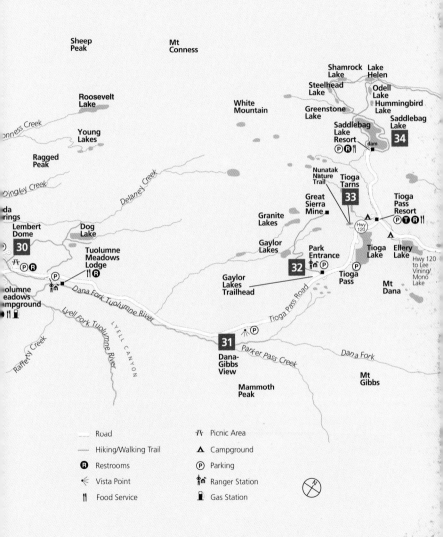

Sheep
Peak

Mt
Conness

Shamrock Lake
Lake Helen

Roosevelt
Lake

Steelhead
Lake

Odell
Lake

White
Mountain

Hummingbird
Lake

Greenstone
Lake

Saddlebag
Lake

Young
Lakes

Saddlebag
Lake
Resort

34

🅿🆁🍴

dam

Ragged
Peak

onness Creek

Delaney Creek

Nunatak
Nature
Trail

Tioga
Tarns

Tioga
Pass
Resort

Dingley Creek

Great
Sierra
Mine

33

🅿🆃🆁🍴

da
rings

Lembert
Dome

Dog
Lake

Granite
Lakes

Hwy
120

30

Tuolumne
Meadows
Lodge

Gaylor
Lakes

Park
Entrance

Tioga
Lake

Ellery
Lake

🅿🆁

🍴🆁

Dana Fork Tuolumne River

32

🏕🅿

Hwy 120
to Lee
Vining/
Mono
Lake

🅿� 🅿

olumne
eadows
mpground

🅿

Gaylor
Lakes
Trailhead

Tioga
Pass

Mt
Dana

🍴🆁

Lyell Fork Tuolumne River

LYELL CANYON

🍴🛢

Rafferty Creek

31

🅚🅿

Dana
Fork

Dana-
Gibbs
View

Parker Pass Creek

Mt
Gibbs

Mammoth
Peak

— Road	🄰	Picnic Area
— Hiking/Walking Trail	⚠	Campground
🆁 Restrooms	🅿	Parking
🅚 Vista Point	🏕	Ranger Station
🍴 Food Service	🛢	Gas Station

N

GETTING THERE

From Yosemite Village head west toward the park exits and follow the signs for Route 120 to Manteca and San Francisco. Travel 15.4 miles from Yosemite Lodge, then turn right onto Route 120 East, following signs to Tioga Pass, Tuolumne Meadows, and Lee Vining. Within the next half-mile you will pass several meadows on both sides of the road: these are the Crane Flat meadows.

BEST MONTHS

June through August.

BEST LIGHT

Early morning, late afternoon, or overcast.

REFERENCES

Color, page 46
Close-up Photography, page 54
Light, page 64

Colorful wildflowers fill the meadows of Crane Flat each summer. The display typically peaks in July, but there can be blooms in June and August as well. Waterproof boots and mosquito repellent are helpful in early summer, when the meadows are swampy.

Soft, overcast light or shade is usually best for photographing flowers, but low-angle sunlight can also work.

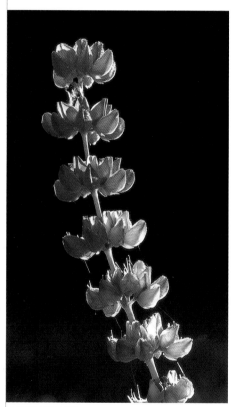

Lupine, Crane Flat.

The Tuolumne Grove 👣

GETTING THERE

From Yosemite Valley head west toward the park exits and follow the signs for Route 120 to Manteca and San Francisco. Travel 15.4 miles from Yosemite Lodge, then turn right onto Route 120 East, following signs to Tioga Pass, Tuolumne Meadows, and Lee Vining. After .6 miles turn left into the Tuolumne Grove parking area.

HIKING DISTANCE

Two miles roundtrip with a 600-foot elevation gain on the way back.

BEST MONTHS

May and October, but good all year.

BEST LIGHT

Overcast or shade.

📷 REFERENCES

Color, page 46
Light, page 64

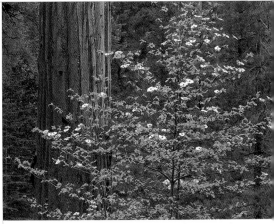

Pacific dogwood and giant sequoia, Tuolumne Grove.

Although this grove of giant sequoias is small, with only twenty-five large trees, it's well worth the hike. The many dogwood trees in the grove make fine photographic subjects, either by themselves or combined with the sequoias. The dogwoods usually bloom in late May, and their leaves turn red and gold in October.

Photographing giant sequoias presents some problems: they are hard to isolate from the smaller trees around them, and the splotchy, harsh light produced by the sun filtering through the forest is difficult to work with. Try to find a viewpoint that allows you to see as much of the tree as possible, or stand at the base of the tree and look up, using a wide-angle lens. The soft, even light of shade or overcast often works better than direct sunlight. 📷

Sunset reflection in Siesta Lake.

GETTING THERE

From Yosemite Valley head west toward the park exits and follow the signs for Route 120 to Manteca and San Francisco. Travel 15.4 miles from Yosemite Lodge, then turn right onto Route 120 East, following signs to Tioga Pass, Tuolumne Meadows, and Lee Vining. This junction is called Crane Flat. Another 14.1 miles from Crane Flat (13.5 miles from 25) you will see a small lake on the right. There is a small paved turnout and a sign indicating "Siesta Lake."

BEST MONTHS

Late September or early October, but good any time the road is open.

BEST LIGHT

Early morning, late afternoon, overcast, or shade.

REFERENCES

Color, page 46
Light, page 64
Using Filters, page 80

Better classified as a pond, Siesta Lake is a peaceful scene of water, grasses, and reflections. In late September or early October, blueberry bushes along the water's edge provide a splash of red fall color. Overcast light or shade usually works best for these subjects. Backlight can also be effective for the grasses, or try photographing clouds reflected in the water at sunset. If you wish to darken or eliminate reflections on the water, use a polarizing filter

27 Olmsted Point

GETTING THERE

From Yosemite Village head west toward the park exits and follow the signs for Route 120 to Manteca and San Francisco. Travel 15.4 miles from Yosemite Lodge, then turn right onto Route 120 East, following signs to Tioga Pass, Tuolumne Meadows, and Lee Vining. This junction is called Crane Flat. Another 30.4 miles beyond Crane Flat (16.3 miles from 26) you will come to a large, paved parking area on the right with sweeping views to the west, south, and east. A sign indicates "Olmsted Point."

BEST MONTHS

Any time the road is open.

BEST LIGHT

Late afternoon to sunset.

REFERENCES

Using Filters, page 80

From Olmsted Point, one of Yosemite's most popular and inspiring viewpoints, you can look west and see the "back" side of Half Dome—the east side, as opposed to the west side seen from Yosemite Valley. To the east lies Tenaya Lake with Mount Conness in the distance. You can photograph right from the parking lot, or walk to the small dome that lies just to the southwest.

There is good light on all of these subjects late in the day. At sunset, Tenaya Lake and Mount Conness will be sidelit in June, and frontlit in October. Low-angle sunlight rakes across Half Dome late in the day, coming from the side in early summer, but more from behind in fall. A 200mm lens or longer is useful for photographing Tenaya Lake and Mount Conness. Practically any lens, from 20mm to 400mm, can be used for Half Dome. A polarizing filter may enhance your photographs here, especially when the scene is sidelit.

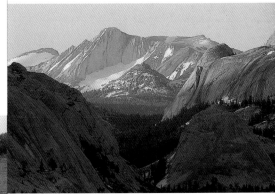

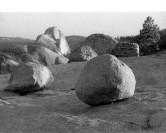

LEFT Glacial erratics with Half Dome in the background.
ABOVE Mount Conness from Olmsted Point.

Using Filters

Filters can be helpful tools to a photographer, but no filter can transform a poor photograph into a fine one. Filters work best when they are used to enhance a photograph, rather than to introduce effects that don't otherwise exist.

For color photography of outdoor subjects, the must useful filters are polarizing, warming, and graduated neutral-density filters. The effects they produce are significant, but subtle. Most people, even professional photographers, can't tell that they have been used.

(1) **A POLARIZING FILTER** is often employed to darken a blue sky, so that clouds stand out more clearly. A polarizer will also reduce reflections on water surfaces (permitting a glimpse of the bottom of a shallow stream bed, for instance), and, by eliminating reflections on foliage, deepen the colors of leaves or grasses.

Polarizing filters usually work best at right angles to the sun—when the subject is sidelit *(Light, page 64)*. If you think a polarizing filter might be helpful in a given

① A polarizing filter deepened the color of the aspen leaves and blue sky in this photo.
② Photographs taken in the shade, such as this image of owl's clover, can acquire a blue tint unless a warming filter is used.

situation, take it out, hold it up to the scene you want to photograph, and rotate it. As you turn the polarizer, you'll notice the sometimes subtle, sometimes dramatic effects it creates, and can judge whether these effects will enhance your photograph. If you don't see any change result from the polarizer, don't use it!

Polarizing filters do have drawbacks. First, they can impart a slight bluish cast to your images, though a warming filter can be combined with a polarizer to compensate (see below). Second, you lose about two f-stops of light when using a polarizing filter, so they're not effective with moving subjects or low light. Third, a polarizer can eliminate important elements of your photograph if you're not careful. For example, a polarizer used at maximum strength will make a rainbow completely disappear! (Rotating a polarizer to its minimum strength will actually enhance a rainbow.)

Pale amber ② **WARM-ING FILTERS** help eliminate the blue tint from photographs taken in the shade. They are only necessary with slide film. With print film, any blue cast to the image can be corrected during printing. Warming filters are designated 81A, 81B, 81C, etc. The 81A has the least effect, with 81B being a little stronger, and so on. An 81B is a good choice for subjects in the shade *(Color, page 46, and Light, page 64).* ▶

③ A GRADUATED NEUTRAL-DENSITY FILTER is half gray and half clear, with a gradual transition between the two sections. It is used to reduce the contrast between bright and dark portions of a scene. Human eyes can look at a scene with sunlit mountains in the distance and deep shade in the foreground, and still see detail in both areas. But film can't capture all components of such a scene. If a photograph is properly exposed for the mountains, the foreground will go black. If the foreground is correctly exposed, the mountains will be washed out. A graduated neutral-density filter can balance the contrast between the two areas when the gray (or neutral-density) part of the filter is oriented over the mountains, and the clear part over the foreground.

There are two types of graduated neutral-density filters: round ones that screw onto the front of your lens, and square ones that slide into a holder that screws onto the front of your lens. The square variety is preferable. With a screw-on filter, the graduated area of the filter will always be positioned in the middle of your photograph. You can slide a square filter up and down in its holder, and even rotate it, to place the graduated area exactly where you want.

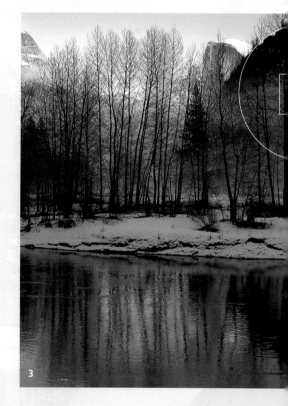

3

There are some inexpensive plastic filters on the market that are not true neutral-density filters. These are called graduated gray filters. There will be a slight color cast in the gray section of these filters, making part of your photographs appear slightly red or blue. True graduated neutral-density filters (both plastic and glass) will not add this tint to an image. Some of these are designed to be extra long, so that you can slide the filter up or down in its holder far enough to position the graduated area near the top or bottom of the picture. Unfortunately, these higher-priced filters retail for $100 or more.

Graduated neutral-density filters also come in different strengths. Some will reduce the light passing through the gray area by one f-stop, some by two f-stops, and some by three f-stops. While most photographers prefer a two-stop filter, the effect they produce can sometimes be glaringly obvious. A one-stop filter produces more natural-looking photographs.

The main limitation of graduated neutral-density filters is that there must be a distinct line between the light and dark areas of the scene you're photographing. They're useless when patches of sun and shade are scattered throughout the image. It's also difficult to see where the graduated area falls as you look at the scene through your viewfinder.

You must use your camera's depth-of-field preview to place the transition area of the filter precisely over the appropriate part of the photograph. Set the desired aperture on your lens, press down the depth-of-field preview button, and slide the filter up and down in its holder. If your camera doesn't have a depth-of-field preview, you won't be able to accurately predict where the graduated area will appear in your photograph *(see Depth of Field, page 100, for more information).*

A graduated neutral-density filter helped to capture detail in sunlit Half Dome as well as in the shaded foreground.

GETTING THERE

From Yosemite Valley head west toward the park exits and follow the signs for Route 120 to Manteca and San Francisco. Travel 15.4 miles from Yosemite Lodge, then turn right onto Route 120 East, following signs to Tioga Pass, Tuolumne Meadows, and Lee Vining. This junction is called Crane Flat. Another 31.9 miles beyond Crane Flat (1.5 miles from [27]) you will see a parking area on the right with a trailhead sign indicating "Sunrise." Park and walk 100 yards further east along the road to the entrance to the old Tenaya Lake campground. Walk into the former campground area and bear left (east) toward the shore of the lake.

BEST MONTHS

Any time the road is open.

BEST LIGHT

Late afternoon to sunset.

📷 REFERENCES

Using Filters, page 80

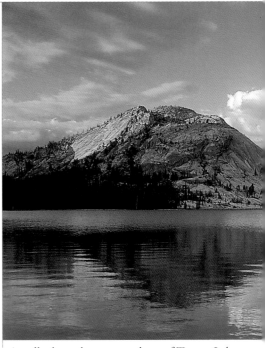

A walk along the western shore of Tenaya Lake reveals views of the deep blue lake with beautiful granite domes in the background. Late afternoon light gives the scene a warm glow. A polarizing filter will increase the contrast in the photograph, but may also eliminate reflections on the water. 📷

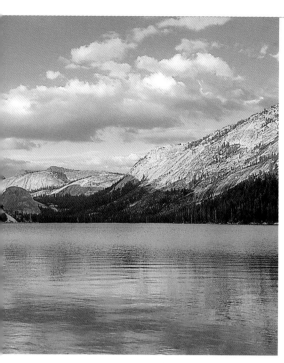

Tenaya Lake,
late afternoon.

29 | Pothole Dome Area

GETTING THERE

From Yosemite Valley head toward the park exits and follow the signs for Route 120 to Manteca and San Francisco. Travel 15.4 miles from Yosemite Lodge, then turn right onto Route 120 East, following signs to Tioga Pass, Tuolumne Meadows, and Lee Vining. This junction is called Crane Flat (6.7 miles from 28). ►

Tuolumne Meadows is one of the most scenic locations in the Sierra, offering countless opportunities for photography. Some of the best are described here, and others are covered in the text for location 30 .

From this turnout you can see the meadow system to the east and the peaks of the Sierra crest in the distance. Immediately north of the road is Pothole Dome. Please do not cross the meadow here to reach the dome—the vegetation has been severely trampled. Instead, walk to your left (west) along the road to the end of the meadow, and double back along the base of Pothole Dome. ►

Another 38.6 miles from Crane Flat you will come to a large grassy area called Tuolumne Meadows. Park in the first paved turnout on the left-hand side of the road. There are interpretive signs at the turnout and a road marker labeled T-29.

BEST MONTHS

June through early August.

BEST LIGHT

Early morning, late after-noon, and sunset.

📷 REFERENCES

*Photographing Waterfalls and Cascades, page 20
Using Filters, page 80*

There is no marked trail to the top of Pothole Dome, but you can easily walk up its sloping, granite slabs. Its summit affords a panoramic vista of the surrounding terrain and is a good place for sunset photography.

The meadow itself serves as a striking fore-ground for the mountains that surround it. In June the peaks are reflected in countless snowmelt ponds. (Waterproof boots and mosquito repellent are recommended in early summer, when the meadow resembles a marsh.) By late June large patches of shooting stars appear, followed by other bright flowers throughout the summer. The peak bloom usually occurs in late July, but may be delayed until early August in wet years.

Most of these subjects are beautifully lit just after sunrise and before sunset. If you attempt to photograph the peaks at times when the meadow foreground is in shade, you may want to use a graduated neutral-density filter. 📷

Pool at sunset, Tuolumne Meadows.

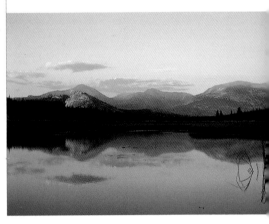

If you follow the edge of the meadow around Pothole Dome and north for about half a mile from the turnout, you will come to a spot where the Tuolumne River leaves the meadow and starts to cascade downward. This series of cascades makes a fine photographic subject, especially in early summer when the river is full from melting snow. Another quarter of a mile down the river are several spots where Unicorn Peak is visible to the south. Both the cascades and Unicorn Peak are bathed in warm light late in the afternoon (about 6 p.m. in June). You may want to put your camera on a tripod and use a slow shutter speed to blur the motion of the water.

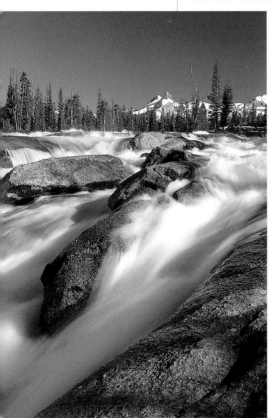

Cascades along Tuolumne River, with Unicorn Peak in the background.

Composition

The cardinal rule of composition is to simplify the picture as much as possible. The most common mistake people make is to include too much in their viewfinders.

Here's a typical scenario. You are walking in Cook's Meadow and look up at Yosemite Falls. In your eagerness to take a picture, you focus your attention on the waterfall only, not noticing all the other things in your viewfinder. These might include rocks, the sky, the meadow, the road, and several motor homes.

When your film is processed, you discover that the falls are a tiny part of the picture. What you thought you were photographing faded into the clutter of a busy scene.

When composing a picture, ask yourself what you're photographing. What is the most interesting part of the scene? What caught your eye in the first place? While you may feel that many subjects demand to be included in the image, try to narrow it down to one or two. Getting three, four, or five different elements to work together in a photograph is nearly impossible.

Once you've chosen one or two main subjects, try to arrange your composition so that you eliminate everything else. Look at several different angles. View the scene from above or below your normal eye level. To simplify the image, move closer to your subject, or use a telephoto lens.

→ beginner
→ intermediate
→ advanced

LEFT The repeating patterns of these grasses create a strong abstract design.
BELOW Half Dome is balanced by the cloud at the top of this image.
FAR LEFT The best compositions are simple, like this photo of frosted grass.

An effective composition also needs to have balance, repetition, and a strong design. The photograph of grasses above has balance because the plants are spread evenly across the photograph, while the multiple, similar shapes of the seedheads create repetition and a powerful abstract design. In the photograph of Half Dome at right, the granite monument at the bottom of the picture is balanced by the cloud at the top. The repetition in this photograph comes from similarities between Half Dome and the clouds (both in shape and color), while the diagonal lines that sweep across the frame from upper left to lower right generate the underlying design.

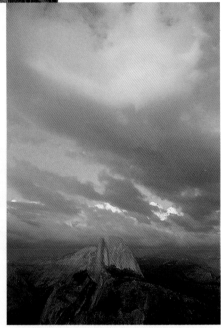

Analyze the composition in some of the other photographs in this book. How do the lines, shapes, and colors work together? Is there a repeating pattern or color in the photograph?

The better you can recognize the use of these design elements in other people's photographs, the more likely you will be to make them part of your own images.

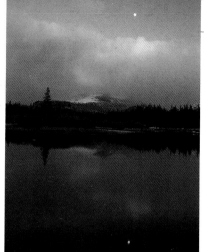

Moonrise over
the Tuolumne River
at sunset.

Lembert Dome is a prominent feature of the Tuolumne Meadows landscape, rising lopsidedly at the meadow's east end. For a superb sunset panorama of the region, take the adjacent nature trail and leave it at marker #2, following the backside route to the top of the dome. The climb is nearly a mile and a half. If you lack the energy or time, try climbing the rock slabs behind the parking area to photograph beautiful glacier-polished granite. The best light is just before sunset.

30 Lembert Dome and Soda Springs

GETTING THERE

From Yosemite Valley head west toward the park exits and follow the signs for Route 120 to Manteca and San Francisco. Travel 15.4 miles from Yosemite Lodge, then turn right onto Route 120 East, following signs to Tioga Pass, Tuolumne Meadows, and Lee Vining. This junction is called Crane Flat. From Crane Flat drive 41 miles to a bridge crossing the Tuolumne River (just past the Tuolumne gas station, grocery store, and campground entrance). Make the first left turn beyond the bridge, then immediately turn right into the Lembert Dome parking area. This location is 2.4 miles from 29. ▶

Just across the main road (Highway 120) from the Lembert Dome parking area is a large pool in the Tuolumne River with nice reflections of Mt. Dana, Mt. Gibbs, and Mammoth Peak. The ideal time to photograph this scene is when the last rays of the sun hit the mountains. A graduated neutral-density filter may be useful here. 📷

To find Soda Springs, walk or drive about a quarter-mile further down the gravel side road to a locked gate. Walk around the gate and continue down this road for about a half-mile to Soda Springs. Drinking the water from this natural mineral spring is not recommended unless you have a strong stomach, but you can safely drink in excellent views of the meadow,

📷 REFERENCES

*Using Filters, page 80
Photographing Wildlife,
page 92*

river, and Unicorn Peak. Early morning and late afternoon light work equally well here.

This is also a good spot to look for high country wildlife: marmots are often seen on the tops of rocks, deer use Soda Springs as a mineral lick in the mornings and evenings during June and July, and Belding ground squirrels are everywhere. 📷

31 Dana-Gibbs View

GETTING THERE

From Yosemite Valley head west toward the park exits and follow the signs for Route 120 to Manteca and San Francisco. Travel 15.4 miles from Yosemite Lodge, then turn right onto Route 120 East, following signs to Tioga Pass, Tuolumne Meadows, and Lee Vining. This junction is called Crane Flat. Continue another 46.5 miles (5.5 miles from ³⁰) to a turnout on the right by a small pond. There is a sign that reads "Dana-Gibbs View."

BEST MONTHS

Any time the road is open.

BEST LIGHT

Late afternoon to sunset.

📷 REFERENCES

Using Filters, page 80

This tiny pond mirrors perfect reflections of Mount Dana (the second highest peak in Yosemite) and Mount Gibbs. The lowering sun often creates vivid colors on the peaks just before sunset. A graduated neutral-density filter may be helpful here at such times. 📷

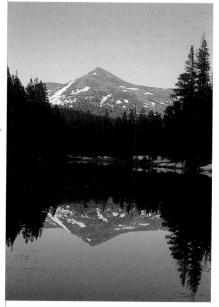

Mount Gibbs.

Small animals, like these Belding ground squirrels, usually look best when photographed from ground level 30.

Photographing Wildlife

Yosemite is famous for its scenery, but not as renowned for its wildlife. While the park may lack the elk, moose, and grizzly bears that attract photographers to Yellowstone, Yosemite is still a great place to photograph animals.

Mule deer are easy to spot and photograph in Yosemite Valley. It's possible to find spotted fawns following their mothers during August and September. In October and November you may be fortunate enough to see bucks "sparring" (locking antlers in a contest of strength). The same bucks will be chasing does around the valley during the "rut," or mating season, of late November and December.

Yosemite Valley is one of the best places in the country to photograph coyotes, but a little work may be required. Some coyotes are more tolerant of people than others. The trick is to find a coyote that will let you follow it, then do your best to keep up (coyotes always trot!).

Eight species of owls reside in the park, making Yosemite one of the best owl-watching locations in the United States. Finding owls requires patience and a knowledge of their calls and preferred habitat.

92A ►

Many other birds—too many to list—reside in every Sierran habitat.

Squirrels, chipmunks, raccoons, and many other small mammals are common throughout Yosemite. Try looking for marmots, pikas, and Belding ground squirrels in the high country around Tuolumne Meadows and Tioga Pass, 30 and 32 .

There's a catch to photographing bears in Yosemite. The black bears that frequent developed areas (Yosemite Valley, for example) are used to being around people and seldom run away unless you're wearing a ranger uniform. But most of these bears have been trapped and sport ear tags, adornments that detract greatly from "wild"-life photographs.

They're also active mainly at night. Bears in the backcountry rarely have ear tags, and are mostly diurnal (active during the day). But when people approach, they run, making photo opportunities infrequent. Occasionally, you will encounter an approachable backcountry bear, or a tagless valley one.

Most wildlife photographs require using a lens that is 300mm or longer, though you can photograph deer in Yosemite Valley with a relatively short lens (an 80–200mm zoom is a good choice). Contrary to popular belief, most professional wildlife photographers use slow speed film (ISO 100 is typical— *Choosing Film, page 68*) and a tripod for photographing animals. ➤

Slow film gives the best image quality, and a tripod ensures sharpness with long telephoto lenses. A ball head on your tripod will make it easy to follow an animal's movements.

Making good wildlife photographs requires the same eye for light and composition as any other photograph. Pay particular attention to what's behind the animal: a distracting background can ruin an otherwise good image.

Long telephoto lenses usually won't provide much depth of field *(Depth of Field, page 100)*. If you can't get the entire animal in focus, then focus on its eyes.

While photographing Yosemite's wildlife, please remember that it's illegal to feed any wild animal in the park. Countless Yosemite bears have had to be destroyed because they learned to associate people with food and became aggressive. Coyotes now stand in the road, begging for food from passing cars. Not surprisingly, several of these coyotes have been run over.

In close-up photographs of creatures like this mule deer buck, focus on the animal's eyes.

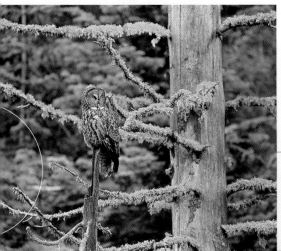

Animals are not the only ones harmed by such feeding. Numerous visitors have been injured by deer in Yosemite, and at least one death has occurred by goring. Although they may seem tame, deer can become aggressive if people get too close.

LEFT Wildlife photographs are often improved by showing some of the animal's habitat, as in this image of a great gray owl. BELOW This black bear photograph benefits from dramatic sidelight.

GETTING THERE

From Yosemite Valley head west toward the park exits and follow the signs for Route 120 to Manteca and San Francisco. Travel 15.4 miles from Yosemite Lodge, then turn right onto Route 120 East, following signs to Tioga Pass, Tuolumne Meadows, and Lee Vining. This junction is called Crane Flat. Continue another 48.2 miles (1.7 miles from 31 *) to the Tioga Pass entrance. Stop just before the entrance station and park in a lot on the left. This is the Gaylor Lakes trailhead.*

HIKING DISTANCE

Reaching the small tarns at the pass requires a short hike with no elevation gain. To reach Gaylor Lakes requires a round trip of two miles or more, with a 500-foot elevation gain going, and a 200-foot climb coming back.

BEST MONTHS

Any time the road is open.

BEST LIGHT

Sunrise, early morning, late afternoon, and sunset.

📷 REFERENCES

*Using Filters, page 80
Photographing Wildlife, page 92*

From the Gaylor Lakes trailhead there are two options, one requiring little effort, the other involving some fairly strenuous hiking. The easy option is to follow the trail that heads south from the entrance station toward Mt. Dana.

Within a flat quarter-mile you will reach several beautiful alpine tarns reflecting mountain peaks. There is good light both early and late in the day. A graduated neutral-density filter may be useful at sunrise and sunset. 📷

The more strenuous choice is to hike to the high alpine basins surrounding Gaylor and Granite Lakes. From the Gaylor Lakes trailhead (just west of the entrance station), follow the trail northwest over a ridge to lower Gaylor Lake. Although you climb only 500 vertical feet to reach the top of this ridge, the thin air at this altitude makes the climb demanding. If you run out of things to photograph at lower Gaylor Lake, the trail continues to upper Gaylor Lake, about a half-mile further. You can

LEFT Reflections in
Lower Gaylor Lake.
BELOW RIGHT
Unnamed peak reflected
in glacial tarn along the
Nunatak Nature Trail.

also head cross-country to the two Granite
Lakes. A topographic map is helpful for finding
your way around this area.

At all of these lakes you can photograph peaks
reflected in the water, alpine flowers, and high
country wildlife, like marmots and pikas.
📷 The cirque behind Granite Lakes gets its
best light just after sunrise, while the ridge
south of Gaylor Lakes is nicely illuminated just
before sunset. Again, a graduated neutral
density filter may be advantageous here. 📷 ➤

33 Tioga Lake and Tarns

GETTING THERE

*From Yosemite Valley head
west toward the park exits
and follow the signs for
Route 120 to Manteca and
San Francisco. Travel 15.4
miles from Yosemite Lodge,
then turn right onto Route
120 East, following signs to
Tioga Pass, Tuolumne Mead-
ows, and Lee Vining. This
junction is called Crane Flat.
Continue another 48.2 miles
to Tioga Pass, drive through
the entrance station (leaving
the park), and proceed for a
half-mile to Tioga Lake. This
location is .5 miles from* 32 .

BEST MONTHS
Any time the road is open.

BEST LIGHT
Sunrise and early morning.

📷 REFERENCES
Using Filters, page 80

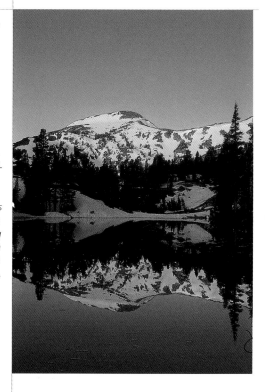

Melting ice, Tioga Lake.

There are two areas described under this location: Tioga Lake and the Nunatak Nature Trail. Photographers will find many viewpoints at Tioga Lake. At the north end of the lake (the far end as you're coming from Tioga Pass), you can look back east across the lake toward Mammoth Peak. To reach the Nunatak Nature Trail, go three-tenths of a mile beyond Tioga Lake and park in the paved turnout on the left-hand side of the road. A short trail leads past two small but pretty tarns.

Both these locations are exceptional at sunrise and in the early morning. A graduated neutral-density filter can improve photographs of peaks reflected in the water. 📷

34 | Saddlebag Lake 🏃🏃

GETTING THERE

From Yosemite Valley head west toward the park exits and follow the signs for Route 120 to Manteca and San Francisco. Travel 15.4 miles from Yosemite Lodge, then turn right onto Route 120 East, following signs to Tioga Pass, Tuolumne Meadows, and Lee Vining. From this junction, called Crane Flat, drive 48.2 miles to Tioga Pass, proceed through the entrance station (leaving the park), and continue another 2.4 miles (1.9 miles from 33). Make the signed left turn ▶

Saddlebag is a man-made lake and not particularly photogenic. But for a modest fee you can hire a boat that will take you to the far end of the lake, where you will find some of the prettiest alpine scenery in the Yosemite area. If you prefer, you can cross the dam at the outlet of the lake and hike to the far end (this will add about 1.5 miles each way to your hike). The boats usually operate from June to early October.

From the far (north) end of Saddlebag Lake there is a four-mile loop trail that leads past numerous alpine lakes. Take the left-hand (west) side of the loop first and hike in a clockwise direction; the finest scenery is on this first stretch. A topographic map is recommended for finding your way around.

onto the dirt road that in 2.5 miles leads to Saddlebag Lake.

HIKING DISTANCE

From a half-mile to four miles.

BEST MONTHS

June through September.

BEST LIGHT

Sunrise and early morning.

📷 REFERENCES

Color, page 46
Close-up Photography, page 54
Light, page 64
Using Filters, page 80

A quarter-mile from the north end of Saddlebag Lake is Greenstone Lake, and Steelhead and Shamrock Lakes are a mile further. These lakes, as well as numerous smaller tarns in the area, reflect magnificent alpine peaks. These scenes are dramatically lit at sunrise, when golden light strikes the mountains. Overcast light or shade brings out the vibrant colors of the many alpine wildflowers in the area. A graduated neutral-density filter may be beneficial in some situations here. 📷

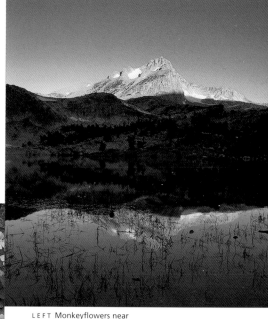

L E F T Monkeyflowers near Shamrock Lake.
A B O V E North Peak reflected in Greenstone Lake at sunrise.

Depth of Field

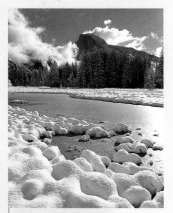

A small aperture keeps everything in this photograph sharp, from distant Half Dome to the snow mounds in the foreground.

Simply put, depth of field is how much of a given photograph is in sharp focus, from front to back. For instance, if your subject is a person standing five feet away backed by a mountain two miles in the distance, just the person may be in focus, just the mountain may be in focus, or the person, the mountain, and everything in between may be in focus.

Professional photographers understand and use depth of field, while most amateurs don't. Professionals know that they can't leave this critical element to chance or to the programmed whims of an automatic camera.

There are times when you may prefer to have only your main subject in focus. By using a telephoto lens set at its largest aperture (usually f/2.8 or f/4), you can make your subject stand out clearly against an out-of-focus background. The further the background is from the subject, the more out of focus the background will appear. This use of shallow depth of field is a common and effective technique for photographing flowers, animals, and people.

For most landscapes, however, you will probably want to place everything in focus. In the photograph above, the snow mounds in the foreground and Half Dome in the background are equally important to the composition; having one or the other out of focus would be distracting.

GETTING EVERYTHING INTO FOCUS

This is the basic five-step procedure for putting everything in a photograph in focus.

1. Compose
2. Focus
3. Set your aperture
4. Set your shutter speed
5. Shoot!

1. Decide what lens you want to use and compose the picture.

2. Focus. This is more complicated than it sounds. Should you focus on the foreground, the background, or somewhere in between? If you said somewhere in between, you're right. But exactly where? To determine this, first focus on the object closest to the camera, and note the distance on your focusing ring (in the first illustration at right, it's three feet away). Next, focus on the farthest thing from the camera, and once again check that distance on your focusing ring (it's at infinity in the second illustration).

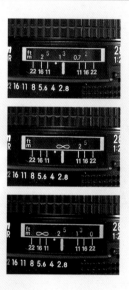

Then set your focus exactly halfway between these two spots on your focusing ring (see the third illustration above). Obviously you'll need to use manual focus for this.

3. Set your aperture. Most cameras have a ring near the lens mount with numbers like 5.6, 8, 11, 16, etc. These number are called f-stops. Turning this ring opens and closes a diaphragm in the lens, varying the amount of light reaching the film. This diaphragm is called the aperture. The higher the f-stop number, the smaller the aperture. Accordingly, a setting of f/16 creates a smaller aperture, or smaller diaphragm opening, than a setting of f/11. Most photographers use the terms aperture and f-stop interchangeably.

➤

The aperture (or f-stop) has a profound effect on depth of field: the smaller the aperture, the greater the depth of field. Once you've figured out where to focus, as in step 2, you will need to determine how small an aperture is needed to get everything from the foreground to the background in focus. There are two ways to do this. The depth-of-field preview is a small button, usually located on or near the lens, that allows you to "preview" the depth of field. To use it, hold down the button while you set progressively smaller apertures. Does everything look in focus at f/8? If not, go to f/11 or f/16 (and so on) until everything looks sharp. You will notice that the viewfinder gets darker as the aperture gets smaller, because less light is coming through that small diaphragm opening. This is normal, but it does make it somewhat difficult to judge what's in focus in low light.

The second way of deciding which aperture to use is using a depth-of-field scale. This is a series of marks on the lens, near the focusing ring, that indicates the distance range that will be in focus at each f-stop. On the lens shown on the previous page, the depth of field scale consists of the paired f-stop numbers below the distance scale. In this example, the scale shows that f/16 will keep all objects from three feet to infinity in focus.

If you don't have either a depth-of-field scale or preview button on your camera, you will have to make an educated guess to select the proper aperture.

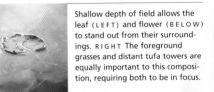

Shallow depth of field allows the leaf (LEFT) and flower (BELOW) to stand out from their surroundings. RIGHT The foreground grasses and distant tufa towers are equally important to this composition, requiring both to be in focus.

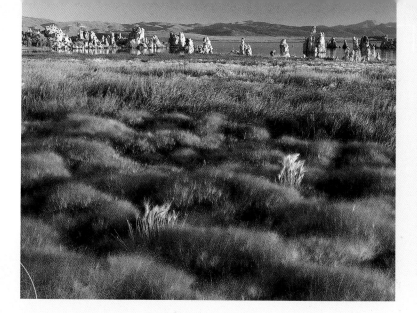

④ Set the shutter speed.
When using cameras with an aperture-priority automatic mode, set the aperture as described in step 3, and the camera will automatically select the shutter speed. In manual mode, turn your shutter speed dial until your camera indicates that you have the correct exposure. See "Exposure," page 110.

There are many different shutter speed and aperture combinations that will give you the same exposure. If you use a smaller aperture to get more depth of field, less light will reach the film, but you can compensate by using a slower shutter speed. For example, all the shutter speed and aperture combinations listed below will produce exactly the same exposure:

1/500th sec. at f/4
1/250th sec. at f/5.6
1/125th sec. at f/8
1/60th sec. at f/11
1/30th sec. at f/16
1/15th sec. at f/22

To achieve greater depth of field, you will often have to work with slow shutter speeds. This is one reason that the use of a tripod is highly recommended. Of course, if you're attempting to freeze the motion of a moving subject, you will probably choose a fast shutter speed and sacrifice depth of field.

⑤ Take the picture!

DEPTH OF FIELD

MONO LAKE & THE EASTERN SIERRA

Although the locations described in this chapter are not within the borders of Yosemite National Park, their wonderful scenery makes them well worth visiting when the Tioga Road is open (usually from late May to the end of October).

MAP 35 → 37

Mono Lake and the Eastern Sierra

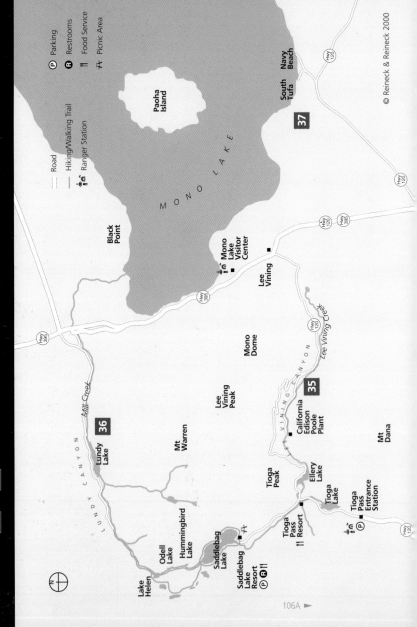

Legend:
- ═══ Road
- ── Hiking/Walking Trail
- 🚻⛺ Ranger Station
- Ⓟ Parking
- Ⓡ Restrooms
- ❚❚ Food Service
- ☂ Picnic Area

© Reineck & Reineck 2000

Paoha Island

M O N O L A K E

Black Point

South Tufa

Navy Beach

37

Mono Lake Visitor Center

Lee Vining

Hwy 395

Hwy 120

Mono Dome

LEE VINING CANYON

Lee Vining Peak

Lee Vining Creek

California Edison Poole Plant

35

Mt Warren

36

LUNDY CANYON

Lundy Lake

Mill Creek

Tioga Peak

Ellery Lake

Tioga Lake

Tioga Pass Resort

Tioga Pass Entrance Station

Mt Dana

Hwy 120

Odell Lake

Hummingbird Lake

Lake Helen

Saddlebag Lake

Saddlebag Lake Resort

106

106A ►

35 Lee Vining Canyon

GETTING THERE

From Yosemite Valley head west toward the park exits and follow the signs for Route 120 to Manteca and San Francisco. Travel 15.4 miles from Yosemite Lodge, then turn right onto Route 120 East, following signs to Tioga Pass, Tuolumne Meadows, and Lee Vining. From this junction, called Crane Flat, drive 48.2 miles to Tioga Pass, proceed through the entrance station (leaving the park), and continue for another 9 miles. Just after the road levels out from its steepest descent, turn right on an unmarked road. Immediately turn right again at a "T" junction (a sign indicates "S. Cal. Edison Poole Plant").

BEST MONTHS

October, but good any time.

BEST LIGHT

Overcast or shade.

[📷] REFERENCES

Photographing Waterfalls and Cascades, page 20
Color, page 46
Light, page 64

This road heads up Lee Vining Canyon 3.4 miles until it dead-ends at a small hydroelectric plant. Along the way it passes campgrounds, aspen groves, and cascading Lee Vining Creek. Although good photographs can be made here any time of year, the best time to visit is when the aspens are turning yellow. It is hard to predict exactly when this will be, but mid-October is a good bet.

The greens and yellows of the aspen forest glow brilliantly in the soft light provided by shade or overcast. [📷]

Icicles in autumn, Lee Vining Creek.

GETTING THERE

From Yosemite Valley head west toward the park exits and follow the signs for Route 120 to Manteca and San Francisco. Travel 15.4 miles from Yosemite Lodge, then turn right onto Route 120 East, following signs to Tioga Pass, Tuolumne Meadows, and Lee Vining. . Continue on Route 120 East for another 60 miles and turn left (north) on Highway 395. After 7.7 miles, turn left on the road to Lundy Lake.

BEST MONTHS

October, but good any time.

BEST LIGHT

Overcast or shade.

📷 REFERENCES

*Photographing Waterfalls and Cascades, page 20
Color, page 46
Light, page 64*

This road leads along Mill Creek, with its many cascades, as it wends its way to Lundy Lake. Near a campground on the route are many pretty creekside locations and some fine aspen groves. Some 5.2 miles from Highway 395 you will reach the Lundy Lake "Resort." Beyond the resort the road becomes a rough dirt road, although it is passable by most ordinary cars. You will pass several beaver ponds before reaching the Lundy trailhead at the road's end (1.5 miles past the resort).

The hike from the Lundy trailhead leads up the canyon past more aspens, beaver ponds, cascades, and a small waterfall, all within a mile of the trailhead. The trail eventually reaches Saddlebag Lake 34 , but most photographers will prefer to skip the grueling ascent of the upper canyon.

Mid-October, when the aspens are turning yellow, is the best time to visit this area, but many wildflowers are scattered along the trail in July. Overcast or shade brings out the subtle tones and colors of these medium- and small-sized subjects. 📷

Aspen grove flooded by beavers, Lundy Canyon.

37 South Tufa and Navy Beach

GETTING THERE

From Yosemite Valley head west toward the park exits and follow the signs for Route 120 to Manteca and San Francisco. Travel 15.4 miles from Yosemite Lodge, then turn right onto Route 120 East, following signs to Tioga Pass, Tuolumne Meadows, and Lee Vining. Follow Route 120 East for another 60 miles and turn right (south) onto Highway 395. After 4.8 miles turn left, continuing on Route 120 East and following the signs for South Tufa. After an additional 4.9 miles, turn left onto a gravel road, also marked for South Tufa. In about 100 yards the road forks; take the left fork to reach the South Tufa area, and the right fork to reach Navy Beach.

BEST MONTHS

All year, but it is difficult to reach this area from Yosemite in winter and spring, when the Tioga Road is closed.

BEST LIGHT

Sunrise; also sunset if there are clouds.

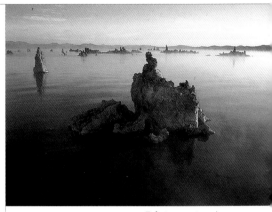

Tufa towers at sunrise, South Tufa, Mono Lake.

From the South Tufa parking area take the short loop trail that leads through Mono Lake's most spectacular concentration of tufa towers. In recent years the lake's water level has been rising rapidly, necessitating frequent re-routing of the trail, but great viewpoints can always be found. This area gets beautiful light at sunrise, and can also be dramatic at sunset if there are some clouds in the sky.

Navy Beach has small, delicate sand tufa formations. The best of these are several hundred yards east of the parking area. Please don't touch any of the sand tufa structures, as they are extremely fragile. The best light conditions here are also at sunrise, but with clouds in the sky, the sand tufas are photogenic from late afternoon to sunset as well. Don't overlook the beautifully textured grasses at both these locations.

Exposure

Exposure is the most technically demanding aspect of photography. Difficult situations, like backlit water, can confuse even experts. But for most conditions, finding the right exposure is easy if you follow a few simple guidelines.

First of all, you're better off setting your exposures manually. If you let your camera automatically select the proper exposure, you usually will get good results in standard lighting conditions. But in unusual situations—the times when the light is most interesting—automatic exposures will leave you disappointed. Even though you may be able to trick your camera into getting the right exposure in automatic mode—by using an exposure compensation dial or an automatic exposure ("AE") lock—using these techniques effectively requires a knowledge of manual exposure fundamentals. Sorry, there's no getting around it!

To understand why exposure can be difficult and why automatic exposures don't always work, it helps to know how your camera's light meter works. In most cameras, the meter reads the amount of light coming from the entire scene you're photographing. If you have both bright, sunlit areas, and dark, shaded areas in your picture, the meter averages their light values. The resulting exposure is a compromise that will leave the sunlit areas washed out, and the shaded areas black.

110A ►

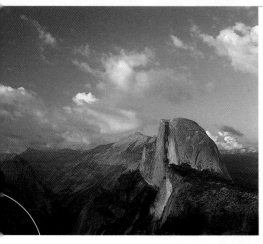

The most important parts of this scene are in the sun, so a meter reading from a middle-toned object in sunlight (like the side of Half Dome) would give the correct exposure.

There is another problem with light meters: they cannot tell whether a subject is white, black, or somewhere in between. Since all light meters are calibrated to middle gray, your meter wants to expose everything as a middle tone. The whitest snow can be darkened to gray, while a black bear's dark fur could be lightened to medium gray.

So how do you deal with all this? The answer is simple: you meter a middle-toned area that's in the same light as your main subject. If something middle-toned is used, light and dark objects won't throw off the exposure. And if the meter is reading just the light that's on your subject and not the rest of the scene, it won't average the light and dark areas together.

For instance, in a sunlit snow scene, you might find a patch of brown grass that isn't covered by snow, and take your meter reading from it. Or you could use your camera bag, your jacket—anything will do as long as it's in the same light as your subject, and as long as it's middle-toned. If your subject is in the shade, choose a middle-toned object in the shade to meter. If part of your scene is in the sun and part in the shade, decide which area is more important, and meter a middle-toned area in the same light. ➤

If you're in doubt about whether something is middle-toned, ask yourself how you would describe it. Is your jacket light red, dark red, or medium red? If it's medium red, it will work. Is the grass light green, dark green, or medium green?

Any color that you would describe as "medium" will be a good subject for a light meter reading. Make sure you fill the frame of your viewfinder with your middle-toned object—you don't want your meter to average in lighter or darker areas from the corner of your viewfinder. Once you've taken your meter reading, use the exposure setting the meter recommends, recompose, and press the shutter button.

Some cameras perform this process in automatic mode. After you've filled the frame with a middle-toned object that's in the same light as your subject, press the camera's "AE" (auto-exposure) lock. This will lock the correct exposure for that area into the camera's memory. Hold the lock down until you take the picture. If you're not sure whether you have an "AE" lock on your camera, check your manual.

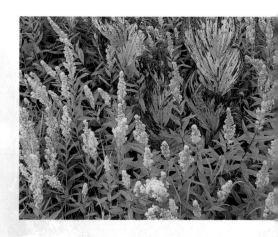

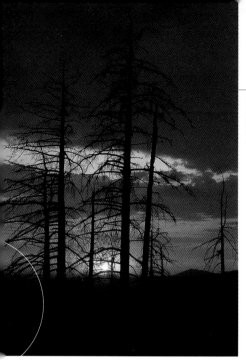

LEFT For silhouettes, meter off of the background. FAR LEFT Automatic exposures work well in low contrast scenes like this.

You have to be careful when using this "middle-tone" method for silhouettes. For example, if you were determining the exposure for the photograph of burnt trees above, it would be easy to choose the wrong setting. If you decided that the main subject was the trees and metered a middle-toned area in the shade, the photograph would be drastically overexposed, washing out the color in the sky. When photographing silhouettes, you must expose for the background rather than for the object that's silhouetted. In this example, a meter reading right off the orange sky near the horizon would be the correct one.

Remember, though, that 98% of the time, a meter reading of a middle-toned area that's in the same light as your subject will serve you well. Even experts rely on this simple procedure.

Seasonal Highlights

Photographic opportunities in Yosemite change dramatically with the seasons. Not only do different seasons offer new subjects to photograph, but the light on Yosemite's cliffs changes significantly throughout the year. For instance, Bridalveil Fall receives no sunlight at all in December, but gets beautiful late afternoon light in April. This section will help you find the best locations for photography at any time of year.

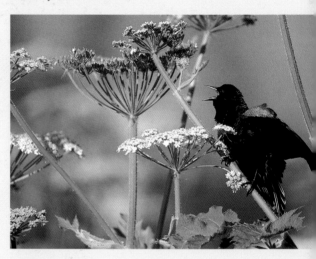

For the purposes of this book, spring is defined as March through May, summer as June through August, fall as September through November, and winter as December through February. Winter is the rainy season in Yosemite; summers are mostly hot and dry, but there can be occasional afternoon thunderstorms, especially at higher elevations. Yosemite Valley, at only 4,000 feet above sea level, gets some of its winter precipitation as snow, and some of it as rain. In the high country, almost all the precipitation in winter falls as snow.

114A ►

SPRING

Yosemite Valley

If you've never been to Yosemite, spring is the time to come. From late March to early June, the valley's famous waterfalls roar with the runoff from melting snow. By late summer and fall, the waterfalls can be reduced to a mere trickle of water, or be completely dried up. See locations 1 , 4 , 7 , 10 , 12 , 13 , 14 , and 16 for some good places to photograph waterfalls.

The most famous view of Yosemite Valley is from Tunnel View, which gets its best light at the time of the equinoxes—for about two weeks before and after March 21st and September 21st. See location 8 .

Half Dome is photogenic any time of the year—see 11 and 12 . Location 2 is a good springtime spot to photograph Cathedral Rocks.

When people think of spring, they naturally think of flowers. Although Yosemite Valley has scattered individual wildflowers, you won't find whole hillsides or meadows full of color. On the other hand, the dogwood trees, which bloom some time between late April and the end of May, put on a spectacular display each spring. Good places to look for dogwoods in Yosemite Valley are around Pohono Bridge 6 , along the road to Mirror Lake 15 , and around Happy Isles 16 .

Merced River Canyon

The most spectacular springtime wildflower displays in the Yosemite area are in the Merced River Canyon, just west of the park. See Chapter 2, the Merced River Canyon, starting on page 48.

ABOVE LEFT Red-winged blackbird and cow parsnip. LEFT Dogwood and giant sequoia in the Tuolumne Grove 25 .

Wawona Area

At Wawona, you can photograph cascades and small waterfalls along the Chilnualna Fall trail 20. Also, look for patches of lupine along Highway 41 near Wawona in May.

Glacier Point Road

The Glacier Point Road is closed for most of spring—usually until late May.

Tioga Pass Road

The Tioga Pass Road is closed for most of the spring, but near its beginning at the Tuolumne Grove 25, you can find dogwoods in bloom among the giant sequoias. These dogwoods live at a higher elevation than those in Yosemite Valley, so they usually bloom one or two weeks later than the valley trees, typically near the end of May. If the valley dogwoods are starting to wilt, head for the Tuolumne Grove.

Mono Lake and the Eastern Sierra

These areas are not accessible from Yosemite during spring, because the Tioga Pass Road is closed.

SUMMER

| Jan | Feb | Mar | Apr | May | **Jun** | **Jul** | **Aug** | Sept | Oct | Nov | Dec |

Yosemite Valley

While June can be beautiful, late summer (July and August) is the least photogenic time of year in Yosemite Valley. By July, the waterfalls are often barely flowing, and there are long periods of cloudless blue sky—great for getting a tan, but photographically mundane. It's also hot and crowded. Even in summer, however, Yosemite Valley is one of the most beautiful places in the world, and there are plenty of things to photograph.

Shortly after sunrise, the sun hits the southeast face of El Capitan 9. There is also good late afternoon light on Sentinel Rock 12 and Half Dome, 11 and 12.

Vernal and Nevada Falls always have at least a little bit of water, even when the other falls have completely dried up. See location 16.

Glacier Point Road

If Yosemite Valley is too crowded for you, head for the high country. Along the Glacier Point Road there are several meadows that have wonderful wildflowers in summer. The peak season for flowers in these meadows is usually about the middle of July, but you should be able to find something blooming all summer long. See location 21. Taft Point and Sentinel Dome 22 are great spots for sunrise and sunset photography throughout the summer.

Although summer is the driest season in Yosemite, thunderstorms occasionally build up in the afternoons. These thunderstorms may produce rainbows and beautiful clouds, and, if you're lucky, the clouds will stay until sunset. Good places to look for rainbows and evening clouds are Sentinel Dome 22, and Washburn and Glacier Points 23.

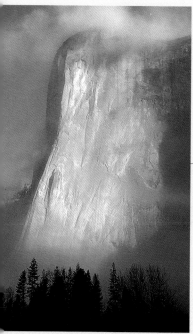

LEFT El Capitan from Cathedral Beach 9.
ABOVE Wildflowers near Summit Meadow 21.

Tioga Pass Road

Along the Tioga Pass Road, Crane Flat 24 and Tuolumne Meadows, 29 and 30, have beautiful summer wildflowers. The peak bloom at Crane Flat usually arrives about the middle of July. In a good, wet year, the optimum wildflower display in Tuolumne Meadows can occur as late as early August, but is more often in mid-to-late July. Many other locations along the Tioga Road (Chapter 4) provide wonderful summer photography as well.

Mono Lake

During the middle of a hot summer day, Mono Lake seems harsh and desolate. But watching the rising sun come up over the glassy surface of the lake, bringing out the texture of the tufa towers, is a memorable experience 37. Also, Lundy Canyon 36 has some nice summer wildflowers.

FALL

| Jan | Feb | Mar | Apr | May | Jun | Jul | Aug | Sept | Oct | Nov | Dec |

ABOVE Half Dome reflection, Cook's Meadow 12.
ABOVE RIGHT Cascade near Happy Isles 16.

Yosemite Valley

Yellow maples and cottonwoods, golden oaks, and red-to-pink dogwoods provide splashes of color among the dark green pines of Yosemite Valley. Unfortunately, these trees do not always turn color at the same time. In some years, the maples and dogwoods change in early October, while the oaks and cottonwoods wait until early November. Occasionally the trees all turn color at the same time, but that phenomenon is hard to predict— your best bet is probably late October to early November. If you're in the valley at the right time, finding fall color is easy—try driving the valley's

one-way loop road *(see "The Classic Views," starting on page 10)* and stopping whenever you see some brilliant color.

As mentioned previously, for two or three weeks before and after the fall equinox (September 21st), the evening light at Tunnel View is at its best. See location 8. In fall, especially late fall, there is excellent sunset light on Half Dome, 11 and 12, and El Capitan, 3, 5, and 9.

Glacier Point Road and Tioga Pass Road

At higher elevations along the Glacier Point and Tioga Pass Roads, there are few deciduous trees, and fall colors are muted. But from September until these roads close in early November, morning frost becomes increasingly common in high country meadows and can make for some beautiful photographs. See locations 21, 24, 29, and 30.

In early to mid-October you can find dogwoods and maples turning color at the Tuolumne Grove 25, near the beginning of the Tioga Pass Road. Blueberry bushes can provide some delightful color at Siesta Lake 26.

Fall offers great sunset light at many locations in the high country. See locations 22, 23, 27, 28, 29, 30, and 32.

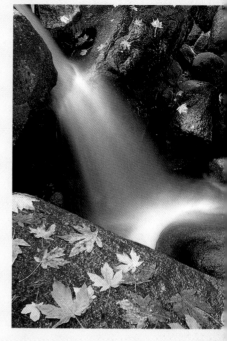

Mono Lake

The best fall color in the Yosemite area is found in the eastern Sierra, where aspens turn yellow and orange during most of October. See locations 35 and 36. The peak time for aspen viewing varies, depending on the elevation and the particular grove of aspens, but mid-October is a pretty sure bet. Sunrise at Mono Lake is remarkable at any time of year 37.

Yosemite Valley

Yosemite Valley is most photogenic just after a winter storm. As the storm clears, mist drapes the cliffs and snow clings to every tree branch. But not for long! As soon as the sun comes out, the snow starts to melt and fall from the trees, which can become bare within an hour of the sun's appearance. Usually, you need to be in Yosemite during a storm if you want to photograph its beautiful aftermath.

You must carry tire chains when driving in Yosemite in winter (it's the law, and it applies even if you have a 4-wheel-drive vehicle), and be prepared for difficult driving conditions and possible road closures. Don't wait until you're in the middle of a blizzard to try putting on your chains for the first time—you'll probably find out that they don't fit. Try them on in your driveway first. You can hear a recorded message with current road conditions, chain requirements, and a weather forecast for Yosemite by calling (209) 372-0200.

Even without snow, winter provides the year's best light on Half Dome, El Capitan, and Upper Yosemite Fall. See locations 3 , 5 , 8 , 9 , 10 , 11 , and 12 . And if you're in Yosemite in February, you should not miss photographing Horsetail Fall at sunset 1 .

BELOW Bridalveil Fall in winter.
BELOW RIGHT Snow-covered alders along the Merced River, near Swinging Bridge 10 .

Wawona Area

The giant sequoia groves are great photo subjects after a snowfall, but you will have to use cross-country skis or snowshoes to get to them. The road to the Mariposa Grove 19 is usually closed after a snowstorm, which means a two-mile ski or snowshoe from the south entrance is required to get there.

Glacier Point Road

With skis or snowshoes, photographers will find that the area around

Badger Pass can provide some good opportunities, especially after a snowstorm. Maps of the cross-country ski trails in the area are available in the park. One of the most popular routes leads to Dewey Point. This is an eight-mile round trip with some tricky downhill sections, and is not recommended for beginners. Experienced skiers will find a spectacular view of Yosemite Valley from Dewey Point. This is a great spot to be at sunset, if you are prepared to camp out (a wilderness permit is required) or ski back in the dark.

The Tioga Pass Road

The Tioga Pass Road is closed in winter, but you can ski to the Tuolumne Grove 25 to photograph snowy giant sequoias.

Mono Lake and the Eastern Sierra

These areas are not accessible from Yosemite during winter, because the Tioga Pass Road is closed.

Sun & Moon Tables

Sunrise and Sunset Times

This is a sampling of sunrise and sunset times throughout the year, calculated for Yosemite Valley. Remember that in Yosemite Valley the best light is usually 30 to 90 minutes after sunrise times, and 30 to 90 minutes before sunset.

	Sunrise	Sunset
Jan 1	7:13	4:48
Jan 15	7:12	5:01
Feb 1	7:02	5:20
Feb 15	6:48	5:35
Mar 1	6:29	5:51
Mar 15	6:08	6:04
Apr 1	5:42	6:20
Apr 15	6:22	7:33
May 1	6:02	7:47
May 15	5:48	8:00
Jun 1	5:38	8:13
Jun 15	5:36	8:20
Jul 1	5:41	8:23
Jul 15	5:49	8:19
Aug 1	6:03	8:06
Aug 15	6:15	7:50
Sept 1	6:29	7:27
Sept 15	6:41	7:06
Oct 1	6:54	6:41
Oct 15	7:07	6:20
Nov 1	6:24	4:59
Nov 15	6:39	4:46
Dec 1	6:55	4:39
Dec 15	7:07	4:40

Daylight Savings Time

Full Moon Dates

	2000	2001	2002	2003	2004
	Jan 20	Jan 9	Jan 28	Jan 18	Jan 7
	Feb 19	Feb 7	Feb 27	Feb 16	Feb 6
	Mar 19	Mar 9	Mar 28	Mar 18	Mar 6
	Apr 18	Apr 7	Apr 26	Apr 16	Apr 5
	May 18	May 7	May 26	May 15	May 4
	June 16	June 5	Jun 24	Jun 14	Jun 2
	July 16	July 5	Jul 24	Jul 13	Jul 2
					31
	Aug 14	Aug 3	Aug 22	Aug 11	Aug 29
	Sept 13	Sept 2	Sept 21	Sept 10	Sept 28
	Oct 13	Oct 2	Oct 21	Oct 10	Oct 27
		31			
	Nov 11	Nov 31	Nov 19	Nov 8	Nov 26
	Dec 11	Dec 30	Dec 19	Dec 8	Dec 26

2005	2006	2007	2008	2009	2010
Jan 25	Jan 14	Jan 3	Jan 22	Jan 10	Jan 29
Feb 23	Feb 12	Feb 1	Feb 20	Feb 9	Feb 28
Mar 25	Mar 14	Mar 3	Mar 21	Mar 10	Mar 29
Apr 24	Apr 13	Apr 2	Apr 20	Apr 9	Apr 28
May 23	May 12	May 2	May 19	May 8	May 27
		31			
Jun 21	Jun 11	Jun 30	Jun 18	Jun 7	Jun 26
Jul 21	Jul 10	Jul 29	Jul 18	Jul 7	Jul 25
Aug 19	Aug 9	Aug 28	Aug 16	Aug 5	Aug 24
Sept 17	Sept 7	Sept 26	Sept 15	Sept 4	Sept 23
Oct 17	Oct 6	Oct 25	Oct 14	Oct 3	Oct 22
Nov 15	Nov 5	Nov 24	Nov 12	Nov 2	Nov 21
Dec 15	Dec 4	Dec 23	Dec 12	Dec 1	Dec 21
	23			31	

APPENDIX B
Resources for Photographers

Camera Walks

The Ansel Adams Gallery, Yosemite Concession Services, and Kodak all offer free photo walks at varying times throughout the year. They are usually 1½ to 2 hours long, and provide an opportunity to pick up some useful tips from a professional photographer. Check the *Yosemite Guide* for specific dates and times.

Workshops

The Yosemite Association offers up to a dozen photography seminars each year on a variety of topics. Seminars are usually two to three days long, are reasonably priced, and are taught by some of the area's leading photographers. You can pick up a seminar brochure at the Visitor Center, or contact the Yosemite Association at:

YOSEMITE ASSOCIATION
P.O. Box 230
El Portal, CA 95318
(209) 379-2321
www.yosemite.org

The Ansel Adams Gallery has revived its workshop program. It offers a diverse selection of courses taught by some of the country's leading fine art photographers. For information, contact the gallery at:

THE ANSEL ADAMS GALLERY
P.O. Box 455
Yosemite N.P., CA 95389
(209) 372-4413
www.anseladams.com

Film, Equipment, Rentals, Repairs, and Advice

A limited selection of film and camera batteries is available at most stores throughout the park. The greatest variety is found at The Ansel Adams Gallery, located next to the Yosemite Valley Visitor Center. Prices for film are virtually identical throughout the park, and are higher than you will find at discount stores in cities.

The Ansel Adams Gallery also offers a small selection of photo equipment and accessories, and rents cameras (including digital cameras), lenses, and tripods. If you're having camera problems or need some photographic advice, you can usually find some knowledgeable photographers working at the gallery to help you.

Although they cannot do major repairs, gallery personnel can check your batteries and sometimes fix minor problems. The closest repair shops are in Fresno, about a two-hour drive from Yosemite Valley.

Film Processing

There is no film processing available within the park. The nearest lab is Photo Express in Mariposa (209-966-2003), about an hour's drive from Yosemite Valley, or at Heidi's in Oakhurst (559-683-8155), about an hour and a half away. Film can be dropped off at The Ansel Adams Gallery for processing at Heidi's; the turnaround is three days.

Images taken with a digital camera, whether your own or one rented at The Ansel Adams Gallery, can be taken to the gallery and printed out or e-mailed. The gallery also has a kiosk which allows customers to make reprints and enlargements from existing negatives and prints.

Phone Numbers

PARK INFORMATION
(including recorded road and weather info)
(209) 372-0200

LODGING RESERVATIONS
(Yosemite Concession Services)
(559) 252-4848

CAMPGROUND RESERVATIONS
(800) 436-PARK (7275)
(International callers use (301) 722-1257)

YOSEMITE ASSOCIATION
(209) 379-2646

THE ANSEL ADAMS GALLERY
(209) 372-4413

Web Sites

NATIONAL
PARK SERVICE
www.nps.gov/yose

YOSEMITE CONCES-
SION SERVICES
www.yosemitepark.com

ONLINE
CAMPGROUND
RESERVATIONS
www.reservations.nps.gov

YOSEMITE
ASSOCIATION
www.yosemite.org

THE ANSEL ADAMS
GALLERY
www.anseladams.com

YOSEMITE STORE
(for books, maps, and
other products)
www.yosemitestore.com

Further Reading

There are countless
books on the market
that can help you
improve your photo-
graphy. Here are a few
that are particularly
relevant to Yosemite
photographers:

**The Nature Photogra-
pher's Complete Guide
to Professional Field
Techniques** by John
Shaw. Published by
Amphoto.

**The Art of Photograph-
ing Nature** by Martha
Hill and Art Wolfe.
Published by Crown
Publishers.

**Photography and the
Art of Seeing**
by Freeman Patterson.
Published by Key
Porter Books Limited.

**The Complete Guide to
Wildlife Photography**
by Joe McDonald.
Published by Amphoto.

NOTES